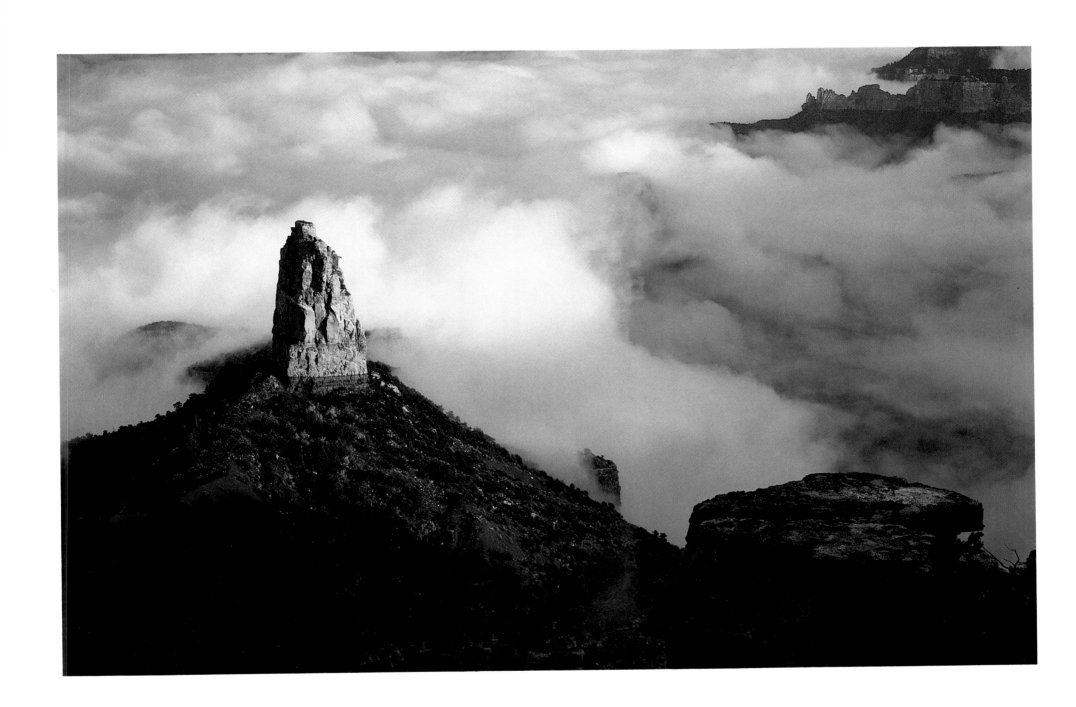

MOUNT HAYDEN FROM POINT IMPERIAL, NORTH RIM

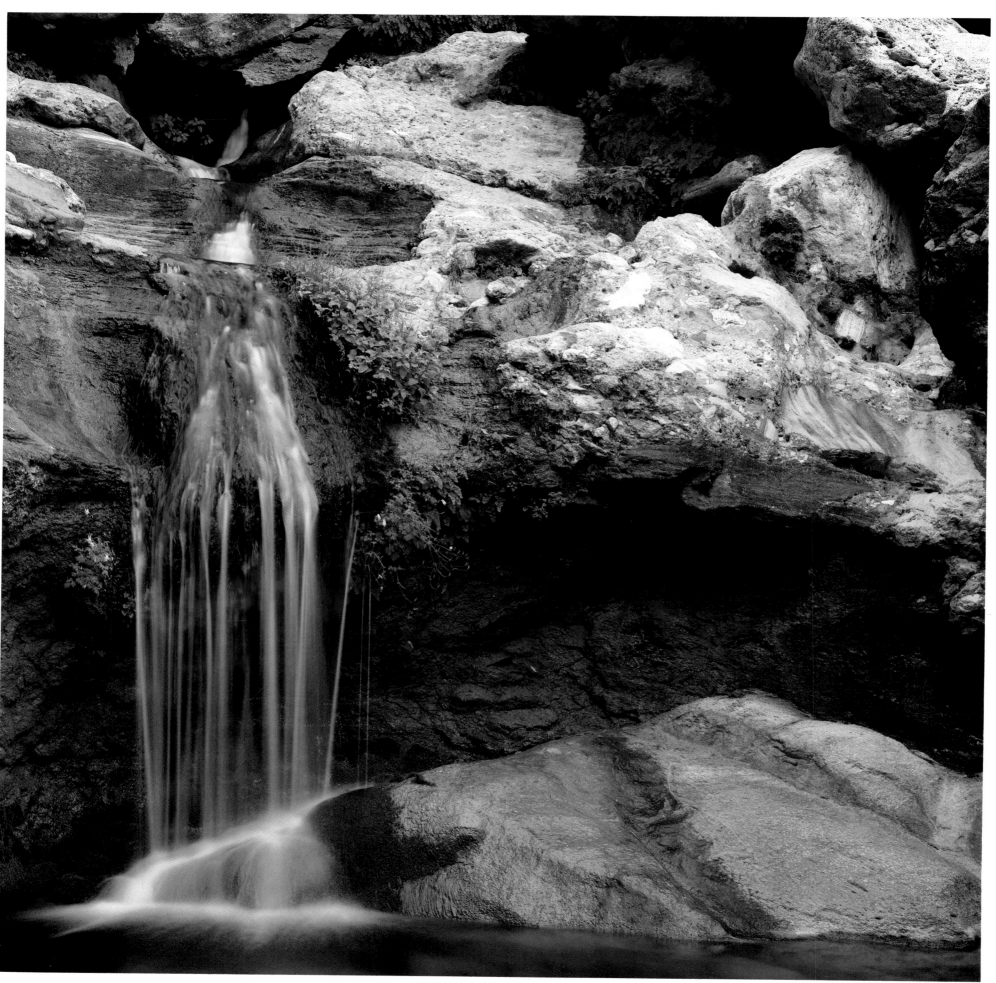

ELVES CHASM, INNER CANYON
OPPOSITE PAGE: ASPENS, NORTH RIM

GRAND CANYON
NATIONAL PARK
WINDOW ON THE RIVER OF TIME

PHOTOGRAPHS BY PAT O'HARA
TEXT BY TIM MCNULTY
DESIGN BY MCQUISTON & DAUGHTER

PUBLISHED BY WOODLANDS PRESS, SAN RAFAEL, CALIFORNIA IN CONJUNCTION WITH GRAND CANYON NATURAL HISTORY ASSOCIATION

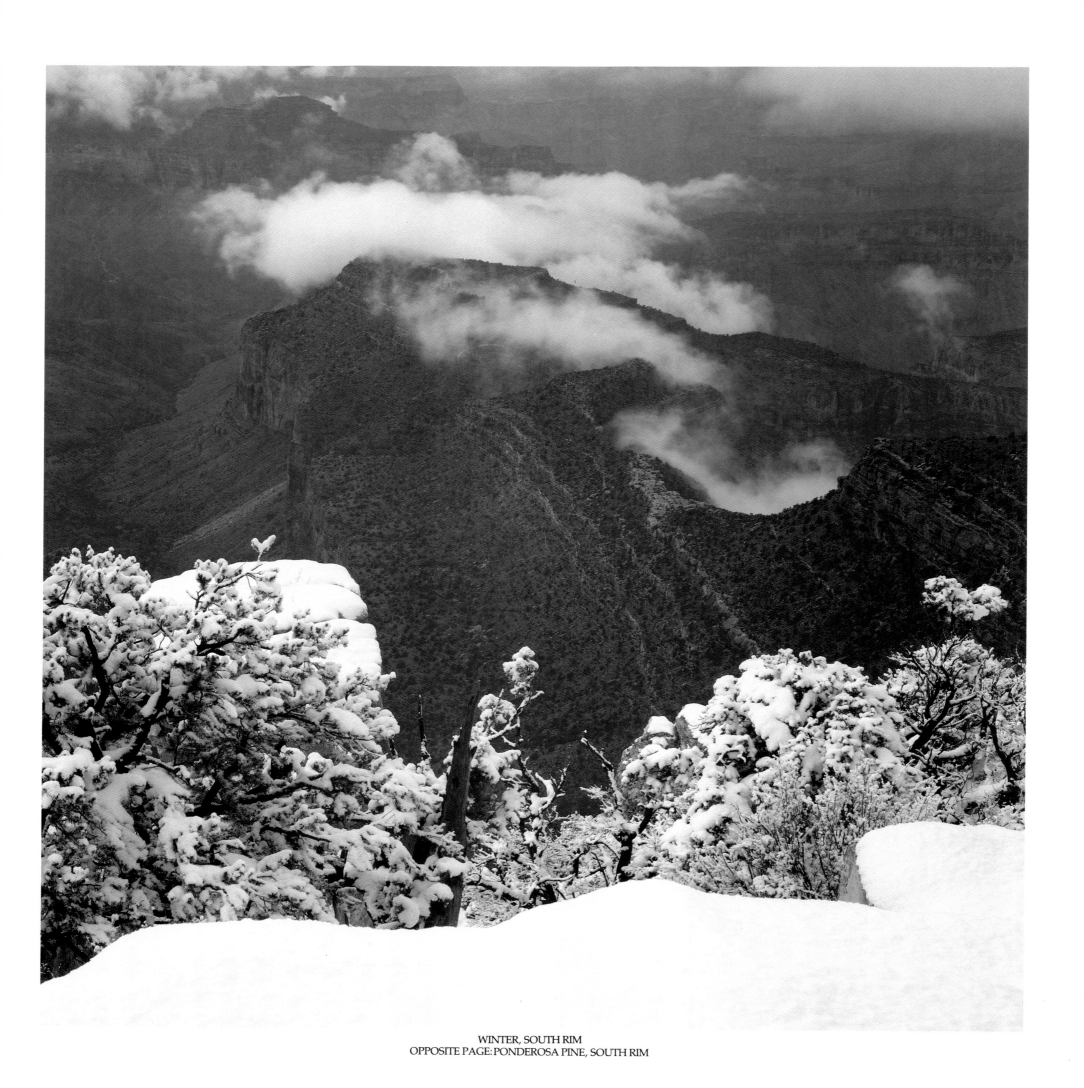

WINTER, SOUTH RIM
OPPOSITE PAGE: PONDEROSA PINE, SOUTH RIM

CONTENTS

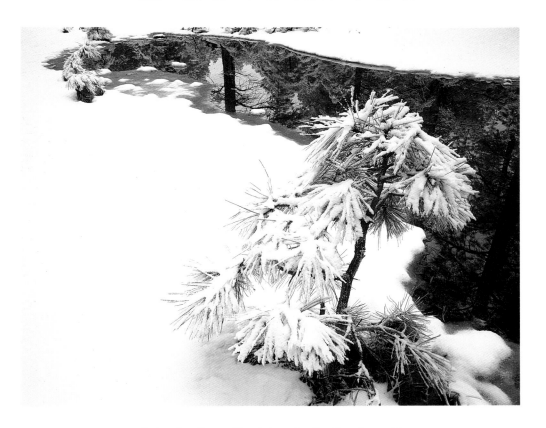

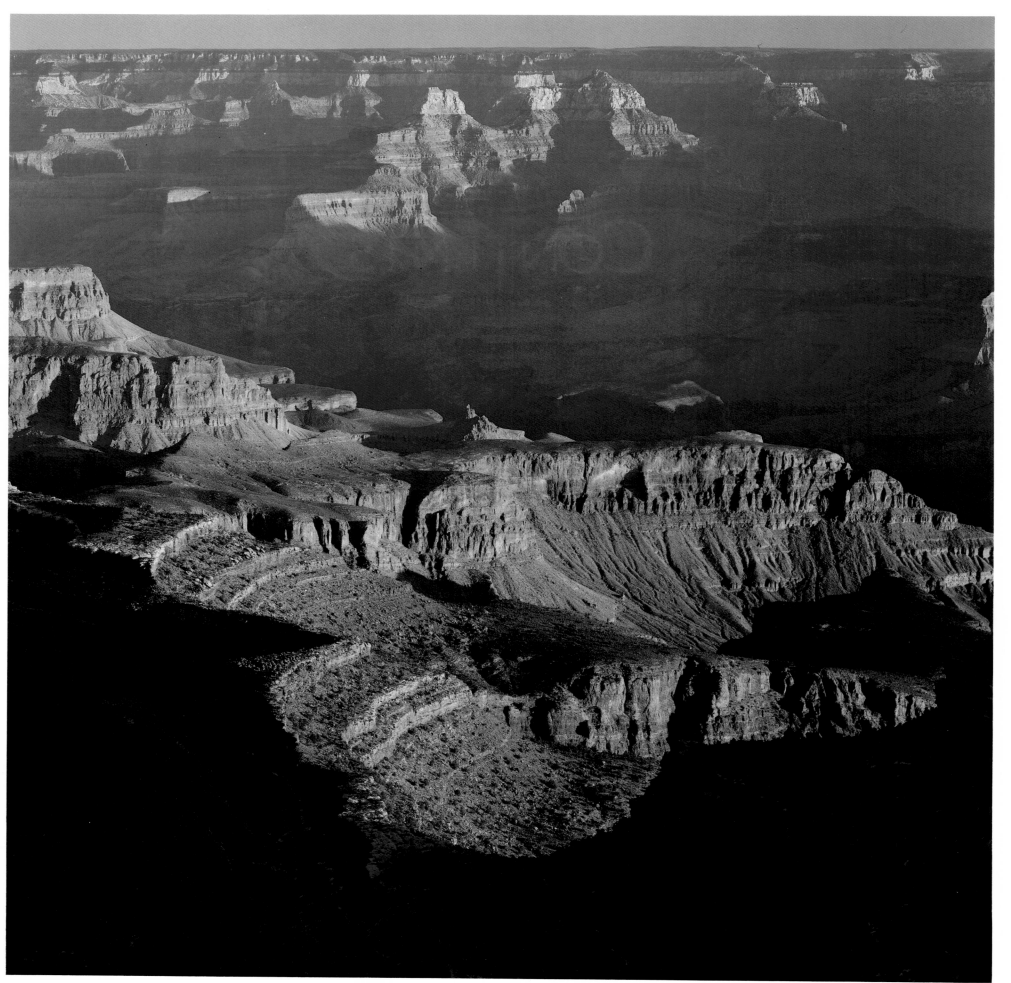

FROM GRANDVIEW POINT, EARLY MORNING LIGHT

FOOTSTEPS IN THE SAND
INTRODUCTION

Although it was still early in the morning, the heat in the inner canyon was intense. After a short hike up from the river, I found a sandy ledge where a light breeze blew past. Just above me, tucked into the base of the Redwall cliff, five small windowlike openings looked out over the swirling waters and high-stepped walls of Marble Canyon. Below me, at the foot of Nankoweap Creek, a wide rolling delta fanned out into the river. The spare desert growth had a pale, parched look. A raven squawked high overhead and a flock of violet-green swallows chirped and twittered as they filled the canyon sky.

Down on the delta, along a shallow rise, piles of rock, broken shards of pottery, and a *metate* or grinding stone, mark the ruins of a small farming village. The Ancient Ones left the Grand Canyon 800 years ago, and their well-tended fields of corn, beans, and squash have long since been reclaimed by prickly pear, agave, and mesquite. Behind me, the doors of their empty granaries remained open to the blowing sand and wind.

In the early 1600s, the Navajo people first entered the Four Corners region from the north. They found the scattered ruins of an older culture and named the people *Anasazi*, the "Ancient Ones." The Anasazi are gone, but from the artifacts they and others have left behind—the fallen masonry of their dwellings, the buried layers of their middens—archeologists have been able to piece together the story of human presence in the Grand Canyon. It is a story that reaches back to that time when people traveled the earth in small family groups in search of game. It traces the beginnings of agriculture, and the early communal village adaptations and artistic refinements agrarian life gave rise to. In some ways the human history of the Grand Canyon is a microcosm of our own passage from hunter to settler. But here that history was played out amid the beauty of one of the most magnificent natural features on earth, a beauty both haunting and splendorous.

For most of us, when we first view the Grand Canyon from its rim, we are taken with its magnitude, the immensity of carved and winding waterways and mazelike passages of terrace and cliff, and the elegant formations of buttes, ridges, and spires. An ever-changing contrast of shadow and light combines with color, texture, and tone to create a spectacle beyond description.

As the softened hazy shapes of dawn fill out and deepen in the slant light of morning, our eyes can follow down the ages of strata—the descending limestone, shale, and sandstone steps of the canyon walls to the deep shadowy metamorphic rock of the Inner Gorge. Two billion years of the earth's history lie before us, revealing not only the geologic history of the continent, but the passage of life itself. From the first simple fossils of algaes found deep in the Bass Limestone through the development of amphibians, reptiles, and cone-bearing trees, the early evolution of life has left its imprint here. Few other places in the world give access to so complete a section of the fossil record. And nowhere else does such a vast and relatively undisturbed portion of the earth's past lie exposed. This timeless aspect of the Grand Canyon, which goes back nearly half the age of the earth, deepens its profound beauty. It is an open window on the great river of time, and through it we see not only the slow procession of events that have formed our earth, but how earth's singular passenger, life, has fared on this journey.

As afternoon clouds build up over the rims, the Canyon's mood changes dramatically. Rolling cloud shadows briefly lift the buttes and temples out of their afternoon haze and lend distinction and sharpness to their varied shapes and contours. In late summer, moist air driven north from the tropics cools abruptly as it lifts over the Kaibab Plateau, and dark mounding clouds give rise to dramatic lightning storms. Activity on the rims is intense, but it is sometimes possible to look out over the Canyon and see the gray falling sheets of rain lit from behind sweep across the sky and evaporate before reaching the hot canyon floors. By evening the clouds have usually broken revealing the sun's long rays that set the intricate topography ablaze with color. Side canyons, alcoves, and grottoes appear in delicate reds and orange-rusts, and sculpted ridges and buttes stand forth in exquisite detail. The colors reach an almost-unimaginable intensity before blue-gray shadows rise out of the depths to extinguish their flames. Here and there a few isolated pinnacles still glimmer to the west. From our various viewpoints along the rim, we are each in our own way carrying on a relationship with this most splendid of canyons—a relationship that began almost four

Indian Paintbrush

thousand years ago when humans first left evidence of their presence here.

It was a mere half-century ago that figurines were discovered in a cave in the Grand Canyon. The figures were fashioned from a single split twig of willow or cottonwood and wound into the shape of a desert bighorn sheep, deer, or antelope. Some had horns, others pellets of deer scat in them, and many were pierced with smaller unsplit twigs resembling spears. They were usually buried beneath rock cairns in nearly inaccessible limestone caves deep within the Canyon. Their protected locations and the dry desert climate preserved them remarkably, leading earlier archeologists to suspect they were of recent origin. They are, however, three to four thousand years old.

It is believed that the people who created and placed these effigies were hunters of the Desert Culture, a culture pervasive in the Great Basin from 7000 to 2000 years ago. Hunting and gathering in small bands along seasonal routes, these people depended on the availability of game. Hunting was limited to the hand-thrown spear, and hunting magic probably occupied a central part of their lives. Imitative hunting rituals may have taken place in the caves where the effigies were found. We do not know how long these early people hunted the plateaus and recesses of the inner canyon, nor why they left. We do know that the simple beauty of the figurines they left for the spirits of animals still speaks to us today. And perhaps, off in hidden caves deep within the Canyon, some of those small woven deer and desert sheep rest with whatever magic they were made for, while beyond their caves the hooves of living sheep and deer continue to drum away the centuries.

The Grand Canyon remained unvisited for fifteen hundred years following the desert hunters, perhaps because of a harsher, hotter climate. But by about A.D. 400 a new group of people entered the Canyon from the east. They were also hunter-gatherers, but they supplemented their economy by growing corn and squash. Their hunting tools had advanced, and soon bows and arrows appeared. The Basketmakers, as they are called, were expert at weaving baskets, sandals, and twined bags from the fibers of yucca, grasses, and other plants. An undecorated gray pottery was produced for cooking and storage. After a short time, these people left the shelter of caves and began to construct circular dwellings dug shallowly into the ground and roofed with brush. A central fire was vented through a smoke hole in the roof. Groupings of these "pithouses" represent the first suggestion of village life in the area.

By A.D. 800, with the security gained by combining efficient hunting techniques with the farming of a new strain of corn, and aided by a pattern of increasing precipitation, the Anasazi entered into a new way of life. (This would eventually flourish into the classic Pueblo tradition evident in the multistoried communal towns of Chaco Canyon and Mesa Verde.) The stability and leisure of communal village life engendered artistic expression. Rock-painting and petroglyphs spread throughout the Canyon. Cotton was introduced from the south and loom weaving took its place in Anasazi culture. There also developed a rich variety of finely wrought decorative pottery for which the Anasazi have become famous. Their multiroom structures contained living areas as well as storage rooms, and suggest a complex social structure born of agrarian life.

Over two thousand Anasazi sites exist in the Grand Canyon, and it is estimated that between A.D. 1050 and 1150 some two-thirds of them may have been occupied. Seasonal use along the river in villages such as Nankoweap, Unkar, and Bright Angel followed spring flooding of fields. The inner canyon offered a longer growing season, available water sources, and many wild plant foods unavailable on the rims. The rims in turn provided ample winter fuel and abundant game, and access trails were established in many drainages. Check dams, runoff channels, and conservation measures came into use at this time, the canyon floor was extensively farmed, and trade was carried on with Indians outside the Canyon. Pueblo life in the Grand Canyon reached its zenith.

One of the groups the Anasazi traded extensively with were the Cohonina people of the western part of the South Rim. The Cohonina adopted many of the material cultural traits of their sophisticated neighbors to the east, but differed from them in many ways.

It was also during this time that subtle changes were taking place in the climate of the region. Shifting seasonal precipitation patterns may have affected crops in the canyon country by the early 1100s. This was soon followed by extensive drought and increasing erosion of the deltas. By 1150 or 1200, the Grand Canyon was completely abandoned. The Ancient Ones were forced to relocate along more permanent water sources. The Anasazi traveled east, eventually settling around the dependable water sources of the Hopi Mesas to become the Hopi people who dwell there today. The Hopi town of Oraibi, the oldest continually occupied settlement in North America, was founded around 1200. The Hopi still visit the Grand Canyon for ceremonial purposes—Sipapu Spring on the Little Colorado is the place of Hopi emergence from the world below, and their sacred salt mines are located a short distance downstream. The Hopi way of life is rooted to the past and to a place as are few other cultures in the New World.

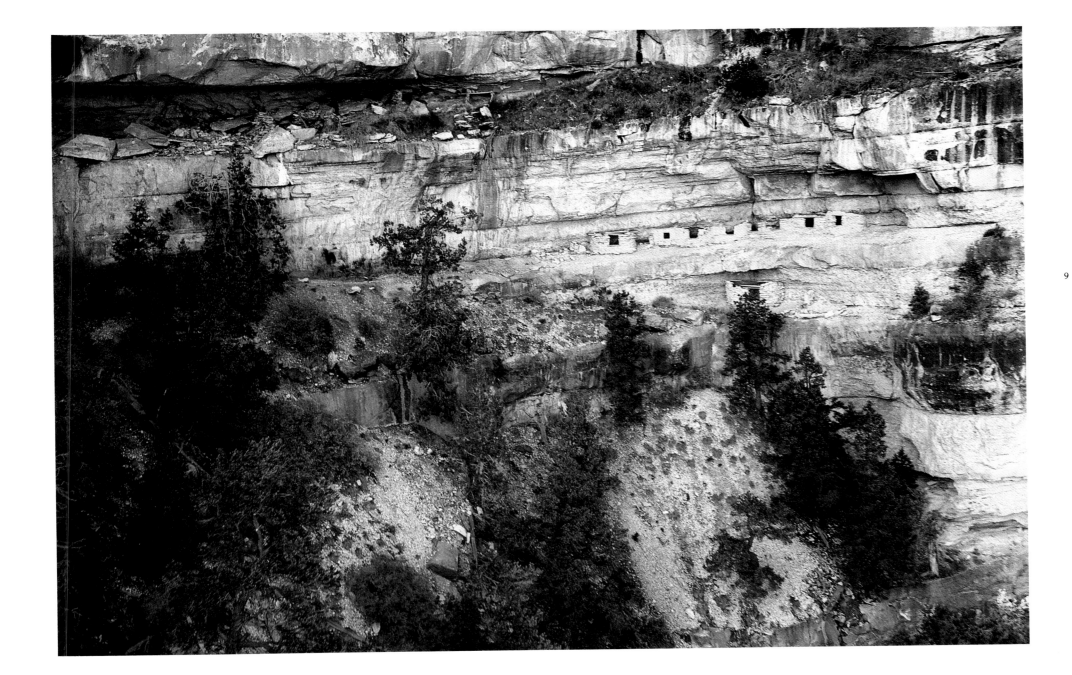

ANASAZI GRANARIES, NORTH RIM. Human presence in the Grand Canyon goes back at least 4000 years. The Anasazi who inhabited the Canyon from about A.D. 400 to 1200 farmed both the rims and the Canyon floor. Corn, beans, squash, and melons were among their food crops kept in pots and stored in these small rock and mortar-constructed granaries tucked into clefts and ledges in canyon walls. Because of their sheltered positions, many of these ancient granaries remain today.

Within a century the Canyon was occupied once more, this time by the Cerbat people who came from the lower Colorado. The Cerbat or Pai ("The People") were the ancestors of the present day Hualapai ("People of the Pine Tree") who inhabit the western part of the South Rim and the Havasupai ("People of the Place that is Green") who dwell in beautiful Havasu Canyon. These cultures adapted well to the resources of the canyon country, and 800 years later their ancestors are still inhabiting the region.

The first Europeans to encounter the Grand Canyon were a small party of Spaniards in 1540. Under the command of Garcia Lopez de Cardenas, they were sent by the Conquistador Coronado to locate the "great western river." Their Hopi guides led them to the South Rim but neglected to show them a route into the Canyon. For three days the Spaniards attempted to descend to the river before giving up the endeavor as hopeless.

In 1826 James Ohio Pattie *claimed* to have led a band of American trappers along one of the rims of the Canyon, but formal exploration of the region did not begin until 1858 with the Ives Expedition. Lieutenant Ives and his party traveled up the Colorado by steamboat to Black Canyon, and overland along the South Rim. Of the area, Ives noted:

The region . . . is, of course, altogether valueless. It can be approached only from the south, and after entering it there is nothing to do but leave. Ours has been the first, and will doubtless be the last party of whites to visit this profitless locality."

Obviously the Canyon's beauty and scientific significance would have to wait for another explorer. Major John Wesley Powell had a scientific background and was versed in geology, paleontology, and ethnology, and combined a driving intellectual curiosity with a taste for adventure. In 1869 he led a small party of four boats down the Green and Colorado rivers taking extensive measurements and notes. He was probably the first to "run" the Colorado through the Grand Canyon—a heroic as well as historic endeavor for its time—and his writings were the first to bring the wonders of the canyon country to the attention of the public. Powell also authored one of the most farsighted land use reports of his day and remains one of the most influential explorer-scientists of nineteenth-century America. In the years following his exploration of the Colorado, Powell became the director of the Geographical and Geological Survey of the Rocky Mountain Region, and he later helped found the U.S. Geological Survey and the Smithsonian Institution's Bureau of American Ethnology.

With Powell's work and the eloquent writings of his protégé Clarence Dutton in 1881, the word was out. The trickle of prospectors and explorers into the Grand Canyon became a stream of sightseers. By 1883, stage coaches were servicing the South Rim, and the following year John Hance opened his "ranch" to tourists. In 1901, rail lines reached the South Rim and hotels began to open in what was to become Grand Canyon Village.

As early as 1882, following Dutton's work, Senator Benjamin Harrison of Indiana introduced a bill to create Grand Canyon National Park. The bill failed to pass either house, but eleven years later as President, Harrison established the Grand Canyon Forest Reserve. Theodore Roosevelt visited the Canyon in 1903, and in 1906 established the Grand Canyon Game Reserve on the Kaibab Plateau. Two years later he created Grand Canyon National Monument by presidential declaration, but the bill establishing a national park was not signed into law until 1919. Since that time, protection of the scenic and geologic wonders of the Canyon has been extended through the creation of adjoining national monuments. In 1975 these were legislatively incorporated into the park with passage of an act that doubled the park's acreage.

The Grand Canyon today is bounded to the east and west by the impounded waters of manmade lakes. Even though the Glen Canyon Dam, located 15 river miles upstream from the park's eastern boundary, has affected the ecology of the river corridor, most of Colorado River in the Canyon remains, for the present, unimpounded. In the mid-1960s the Bureau of Reclamation proposed the construction of two dams within the Canyon at Bridge and Marble canyons, and some exploratory drilling took place. A citizens' campaign mounted against the projects drew national support and the proposals were defeated. The river that carved this magnificent canyon continues its work. Canyon walls ravel incrementally back into the plateau as the Colorado widens and deepens its bed. In a few centuries, the manmade lakes will be filled with sediments and a muddy, debris-laden Colorado will continue its transformation of the landscape. In possibly less time than the river took to carve this awesome chasm, its erosive powers will have reduced it to a wide, rolling plain.

Such is the way with rivers and canyons. They are brief moments in geologic time. The walls of the Canyon show us this in their vanished ranges and layers of ocean floor. For our part, we can be grateful that our moment and the Canyon's have coincided. For four thousand years we have shared something of our time together. We have added our footsteps in the sand to the long heritage of this place, and it has given to us a glimpse of the journey that brought us here.

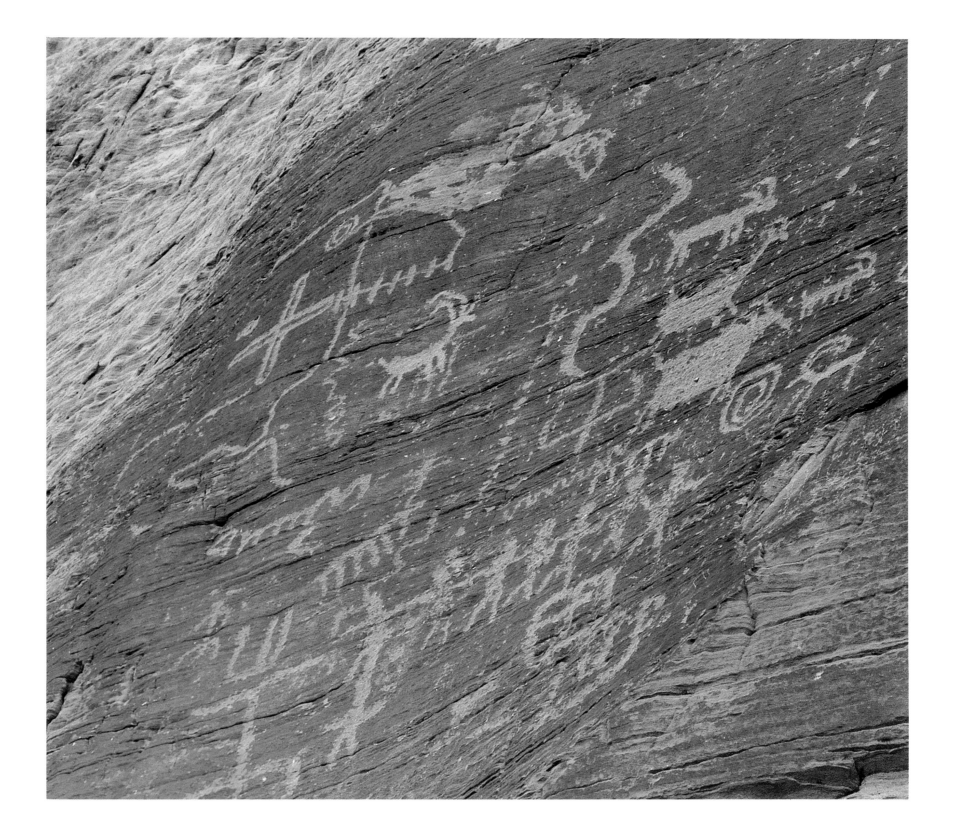

PETROGLYPHS. Rock painting and petroglyphs can be found throughout the canyon country. They are difficult to date and their meanings have largely been lost. But these creations speak of a time when human and natural worlds were closely linked. Animal shapes and symbols pecked into the dark magnesium oxide on a canyon wall represent some of the earliest art in the Southwest and provide a bridge between our culture and those who went before us.

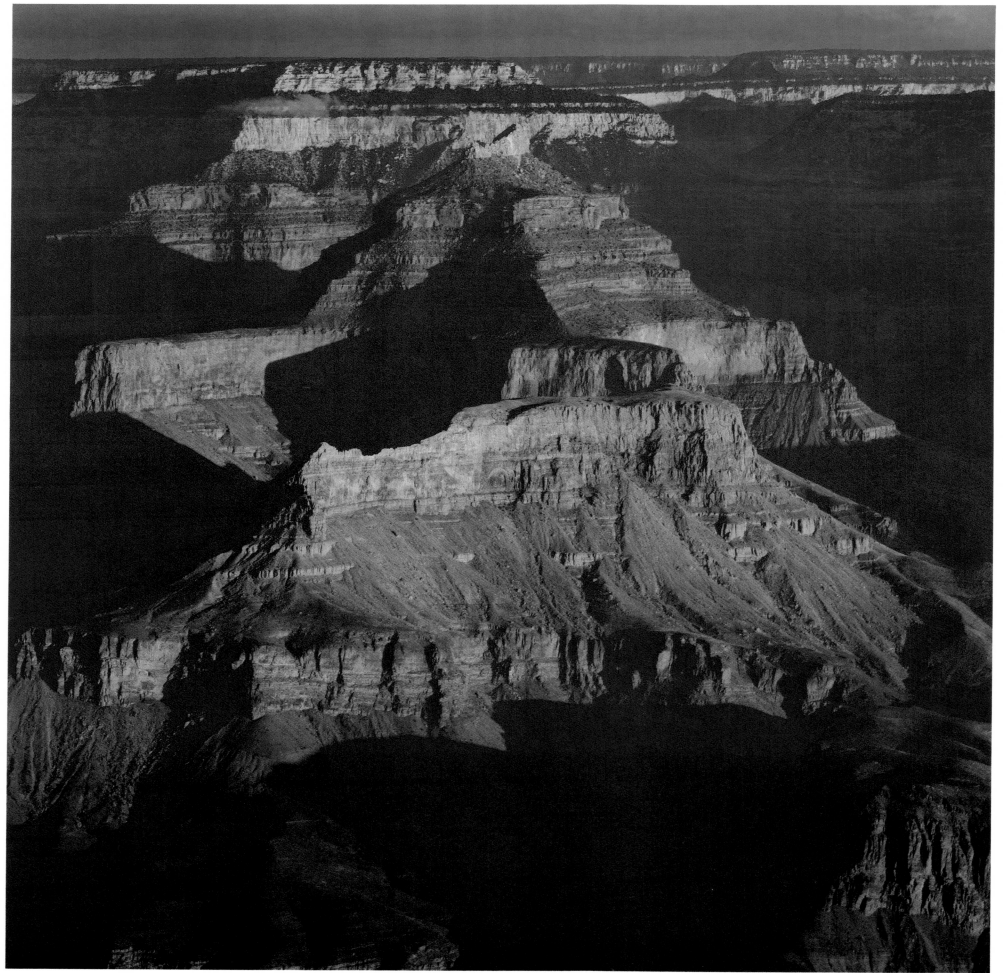

CHEOPS PYRAMID AND ISIS TEMPLE FROM YAKI POINT

THE HIGH DESERT'S EDGE
THE SOUTH RIM

The stillness in winter along the South Rim is a special stillness. True, the ever-present ravens are seldom at a loss for words, and juncos frequently twitter through the pines and junipers. But when the rim is blanketed with snow and clouds lie low over the depths of the Canyon, even the squeak of boots seems hushed. Most years the South Rim gets its first dusting of snow in October. It usually doesn't last long, but the return of the Oregon juncos from their summer range in the Rockies and the pale yellow and tan of the Gambel oak leaves signal the coming cold months. Mule deer suddenly seem more abundant on the rim and feed heavily on the fall forage, and at Grandview and Desert View, acorn woodpeckers can be seen caching their winter food supply in the hollowed-out pockets of ponderosa snags.

Fall is always a season of contrasts in the Canyon. One October, I began a hike in a hailstorm. Dark-bottomed storm clouds filled the Canyon and an icy wind shook the trees. Within minutes the ground was white. As I pulled up my hood and started down the Kaibab Trail, a fragment of sky opened and the sun cast a bright rainbow across the darkened landscape. In a short time the hail had given way to a light rain, and by the time I reached the arid Tonto Platform at the base of the Redwall, I'd shed both raincoat and sweater. Later, in the bottom of the Canyon at Bright Angel Creek, it was a balmy 80° F with dark clouds still clinging to the rims above.

As the Kaibab Plateau rises up out of the larger Colorado Plateau, it creates a cooler, moister climate for itself. Sage lands of the Colorado Plateau grade into high-desert forests of pinyon pine and Utah juniper, and summer thunderstorms and winter snowfall become common. At around 7000 feet, the South Rim just begins to get a taste of a mountainlike climate when it is cut off abruptly by the Grand Canyon. The North Rim, some ten miles away and about a thousand feet higher, hosts a remarkably different ecosystem. Extensive montane forests of spruce and fir replace the pine-juniper forests, and the rising landscape is dotted with breezy stands of aspen and grassy meadows. Rainfall, winter snow accumulation, and average temperature differ markedly, and the varying habitats have given rise to distinctively different plant and animal communities.

Winters on the South Rim are mild by comparison. Snow will often melt back during the coldest months, and spring seems to move up quickly from the early budding of cottonwoods and redbuds that line streambanks and washes deep in the inner canyon.

Spring first arrives on the South Rim with flocks of bluebirds. Western bluebirds winter in lower portions of the Canyon and return to the rim in March where the deep blues of their wings flash brightly over the lingering snow. As snow melts back in April, the clustered white and red-tipped blooms of wood betony are often the first to greet the warming rays of the sun. They are soon followed by lousewort, and in moist years the spreading pink, purple, and white blossoms of desert phlox will carpet the ground beneath the pines and junipers. Steller's jays and pinyon jays rasp through the trees, and chipmunks and tassle-eared squirrels are frequently seen scurrying across the duff.

But it is just over the rim itself, in the cool, shaded, north-facing headwalls and grottoes that the full beauty of spring hides itself. Snow lingers longer into the season here and a unique microclimate develops. Douglas-fir and white fir are not uncommon, and in May when the pine-juniper forests of the South Rim are beginning to appear spare and dry, the wildflower gardens just below the rim are alive with color and freshness. They are almost more suggestive of high mountain meadows than the arid Colorado Plateau. A short walk down the Bright Angel or Grandview trails during this time takes one through stunning displays of scarlet penstemon, paintbrush, and pale gold aster. The dark liquid blue of Nelson larkspur dots the rocky slopes. Bushy growths of cliffrose and Apache plume are littered with small cream-colored and white flowers, while thick beds of blue lupine cover the moister slopes. A warm breeze drafting up against the canyon walls carries the sweetened scent of spring, and cool green ferns and grasses rustle lightly in the shadows. This is a wonderful time for day hikes into the Canyon. Often I've left early in the morning dampness and hiked down through the upper cliffs with lush grottoes of nodding wildflowers, only to return from the dry heat of the inner canyon to the freshness of these spring gar-

Desert Five-Spot

dens in cool evening shadows. It's a good way to begin a walk and a fine way to end one. Up on the rim, there may be the lingering yellow bloom of a western wallflower or small white petals winking from a serviceberry bush, but it's obvious the party has moved elsewhere. Unless you follow it over the edge you're missing one of the South Rim's special events.

Grandview Point is well named. Its view is one of the finest in the park, and the hike down the Grandview Trail to Horseshoe Mesa is a favorite. Many of the major features of the Canyon are easily seen from Grandview. From the Palisades of the Desert to the east to Shiva Temple and Point Sublime to the west, the sculpted forms of the heart of the Canyon compose a landscape unparalleled in scenic beauty. As we look at the complex array of temples and spires rising up out of the fanned blue-gray skirts of the Tonto Platform, it's difficult to grasp that this magnificent topography owes both its final shape and much of its initial deposition to the powers of moving water.

Nearly 3500 feet below, the Tonto Platform tips off abruptly into the Inner Gorge. The Colorado River visible far to the east seems swallowed up by the dark precipitous walls of the gorge as it slices its way west through the more orderly sedimentary rocks above it. The Vishnu schists of the Inner Gorge are all that remain of a once-massive mountain range that dominated this region about 1.7 billion years ago. The rocks that formed it were sediments and volcanic materials probably deposited two billion years ago. Under the tremendous pressures and heat that accompanied the uplift, these sediments were chemically altered and fused into the tough metamorphic rock that forms the gorge. The lighter, pink-colored rock visible in vertical bands is Zoroaster granite, formed when molten material from below pushed up into cracks and fissures and cooled at great depths. Over hundreds of millions of years, this great range eroded down to a wide low plain. During this time of erosion, no new rocks were deposited, and the gap in the geologic record here amounts to about 500 million years.

About 1.2 billion years ago in the late Precambrian period, the land subsided beneath a sea. Marine algae, the oldest forms of life to leave their trace in the Canyon, helped deposit calcium carbonate along the floor of this sea. This combined with silts and clays to form the Bass Limestone. The sea probably advanced and retreated over the area several times to deposit numerous sandstones, siltstones, and shales that are now called the Grand Canyon Supergroup. These rocks reached a tremendous thickness before they were broken into blocks and uplifted into a second, high mountain range. These mountains in turn were gradually eroded down to remnant hills scattered across the older plain of Vishnu schist.

Six hundred million years ago with the beginning of the Paleozoic era, this landscape was submerged beneath a Cambrian sea, and deep layers of sand built up over both hills and plain. The dark brown cliffs of Tapeats Sandstone resulted. When John Wesley Powell encountered its horizontal bands capping the exposed tilted strata of the remnant hills beneath it, he dubbed it the Great Unconformity. This formation occurs throughout the Canyon and represents a gap of between 300 million and 1.3 billion years. From Grandview, the Great Unconformity is visible directly below, where the dark rocks of the gorge meet the brown horizontal strata just beneath the Tonto Platform.

It was in the sea of the early Paleozoic era that the first definite signs of animal life appeared. As the sea advanced across the land, the sandstone formed from its beaches was gradually covered with silts carried by rivers, forming shale. As the sea deepened, shales accumulated on its floor. Today this sequence is represented by the Bright Angel Shale and the Muav Limestone formations, the rocks that form the Tonto Platform. Easily eroded, these rocks have weathered down almost to the Tapeats Sandstone beneath them.

Not far from Indian Gardens on the Tonto, numerous primitive sea animal fossils have been found. Some were small, shelled creatures called brachiopods and hyoliths, but the largest, most numerous and presumably most notorious, were the crablike trilobites. These small, armored creatures dominated the marine environment for hundreds of millions of years, feeding on their less well-armored neighbors. Their fossils are found even in the Kaibab Limestone that caps the rims.

Following the Cambrian period, the area that was to become Grand Canyon was probably lifted above sea level for an extended period. Consequently, no rocks were deposited to record the first fish to appear in the seas or the first air-breathers to venture onto land. Some sediments from this time did fill in scattered river valleys cut into lower strata, and bits and pieces of the bony plates that armored the earliest fish are present in these deposits.

As you look out from almost any point on the Canyon's rims, the prominent 500-foot cliff of red-stained limestone stands out above the Tonto Platform. This is the distinctive Redwall cliff that erodes into vast alcoves, caverns, and caves. The nearly pure limestone of the Redwall indicates deposition in a wide and quiet sea. For nearly 30 million years the remains of plants and animals rained down on the sea floor, and combining with calcium carbonate from seawater, solidified into limestone. Sea life was abundant at this time, and along with trilobites and brachiopods, fossils of clams, snails, sea lilies, and fish are found.

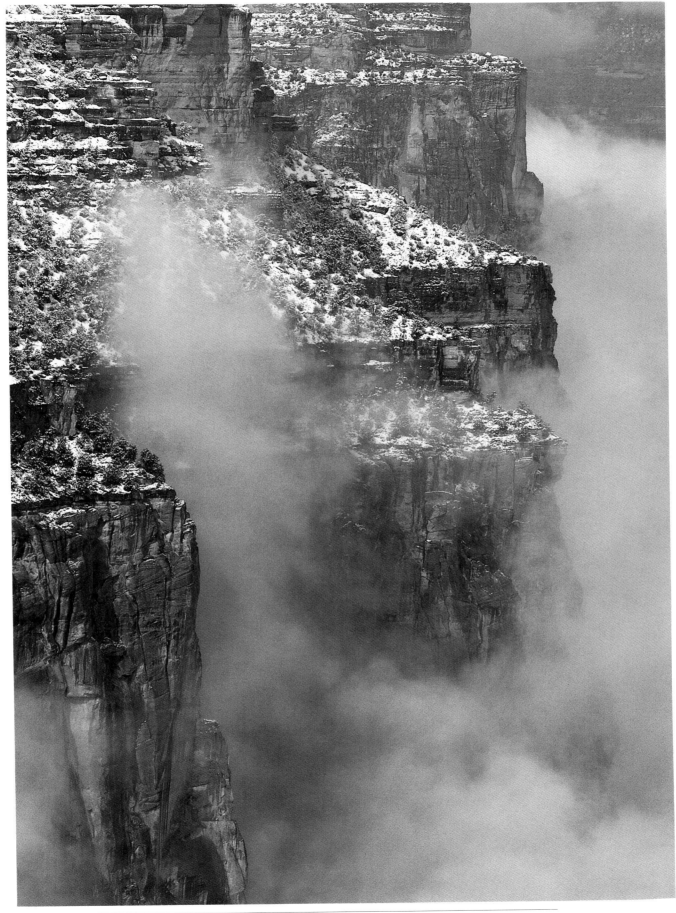

SLOPES AND CLIFFS FROM LIPAN POINT. Grand Canyon topography is the result of erosion by water, wind, frost, and gravity. Some sedimentary rock layers weather into slopes of rubble; other more resistant layers form cliffs. Here, portions of the Kaibab, Toroweap, and Coconino formations are accentuated by a late winter snow and softened by drifting clouds.

The layers of stepped ledges seen above the Redwall represent the Supai Group. After the great sea that formed the Redwall retreated, another interval of erosion took place. When the land again subsided, more limestones, sandstones, and shales were deposited by low retreating seas and rivers. The environment at this time was hot and arid. Land plants growing along streams and swamps left fossil imprints that include those of the familiar horsetail rush. The tracks of some of the earliest reptiles and amphibians were also left in the soft muds along watercourses. Oxides leached from these shales are responsible for the red stain on the normally gray limestone cliffs of the Redwall below.

The topmost layer of red shale in the Canyon was laid down as mud and silt by slow-moving rivers from the north and east. This early Permian period was marked by an increasing diversity of small salamander-like creatures, winged insects, worms, and an abundance of land plants that include ferns and early cone-bearing plants.

Above these Hermit shales, as they are called, lies a well-defined cliff band of tan- or cream-colored rock. The Coconino Sandstone tells of an increasingly arid climate where desert conditions prevailed similar to those of the Sahara. The shapes of blowing dunes can be seen in the cross-bedding of this rock layer, and slabs of sandstone contain the fossil footprints of reptiles as well as the smaller tracks of the invertebrates that were their prey.

Along both rims, two layers of buff-colored and yellow-gray rocks are exposed as cliffs and are usually separated by a tree-covered slope or step. The Toroweap Formation on the bottom and the Kaibab Limestone on top are both the result of a warm sea that twice invaded the region in the late Permian. The first invasion drowned the dunes of the Coconino and laid down the Toroweap rock. Then came a deeper immersion that deposited the Kaibab limestones. This sea was quite extensive, and within its thick rock layers we can find evidence of a richly burgeoning evolution of sea life. Corals, sponges, mollusks, shark's teeth, and a graceful conchlike creature, a cephalopod, have been identified.

The Kaibab limestones of the rims were laid down over 250 million years ago. Since then, as much as 8000 feet of river-borne sediments and wind-blown sand covered them. Few of these rocks remain on the Kaibab Plateau today however. Cedar Mountain near Desert View, and Red Butte beyond the southern boundary of the park, stand as remnants of these Mesozoic formations.

At the close of the Mesozoic era about 65 million years ago, western North America underwent a profound mountain-building episode called the Laramide Orogeny. Tremendous compressional forces uplifted the Rocky Mountain chain from Canada to Mexico. The uplift of the Colorado Plateau also dates from this time, and along with it, the Kaibab Plateau. The near sea-level layer of the Kaibab Limestone was lifted as much as 9000 feet, and the rocks above them were all but stripped away by erosion.

It would still be another 60 million years before the Colorado River would carve the chasm of the Grand Canyon. During that time the area would again feel the effects of another mountain building episode, the Basin and Range Orogeny to the west. The basins, faults, and monoclinal folds created by these two disturbances provided the connecting links for the series of events that resulted in the final carving of the awesome canyon that lies before us.

It was getting late. The sun had long since slipped past the rim and the stiff wind that had blown all day from the southeast had at last died down. I'd managed to while away the better part of the afternoon perched on the northwest point of Horseshoe Mesa, with my feet over the edge of the Redwall and the pages of my notebook flapping against my arm. A thousand feet below, the Tonto Platform dropped off silently into the Inner Gorge, and across the Canyon, the broken ridges and terraced cliffs of Krishna Shrine, Vishnu Temple, and the massive forest-capped butte of Wotan's Throne were lit with that diffused candlelike glow that often lingers into dusk. To the east and far below me, the river took a sharp bend around the foot of Solomon Temple, flashed dimly as it danced across Hance Rapid, and vanished into the shadow of the gorge.

My camp was at the other end of the mesa, and I still had to descend several hundred feet to a spring before cooking dinner. As I hiked back past the tall crescent of Supai shale that crowned the mesa, my better judgment must have gone on ahead. It was almost dark as I scrambled over the last blocky step to the summit. The sky glowed faintly off to the west. I turned to the east where the sky darkened to a rich cobalt blue, and there the full moon rose perfectly through a notch above a Redwall cliff and cast its pale sheen over the breathless evening landscape.

The full moon.

I remembered then. It was the reason I'd first decided to camp there that night. And it almost rose without me.

ICE DESIGN, SOUTH RIM. Winters on the South Rim are neither as long nor as severe as North Rim winters, but temperatures can plummet to well below freezing and snow often blankets the ground for weeks. Winter is a quiet time on the South Rim. Quiet but not completely still. Skiers and snowshoe hikers often encounter the tracks of animals that stay active during the winter months. Rabbit tracks abound, and occasionally one may find the large prints of a mountain lion stalking its prey.

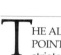HE ALLIGATOR BELOW MOHAVE
POINT. In afternoon light the
striate reddish-brown layers of
the Supai Group (shales and
sandstones deposited by rivers
and shallow seas) are intensified.
To the right, the pale buff-colored
rocks of Coconino Sandstone tell
of a past desert climate in which
blowing dunes formed a thick
band of sandstone. The Grand
Canyon is one of the very few
places on earth where the
geologic record is well exposed.

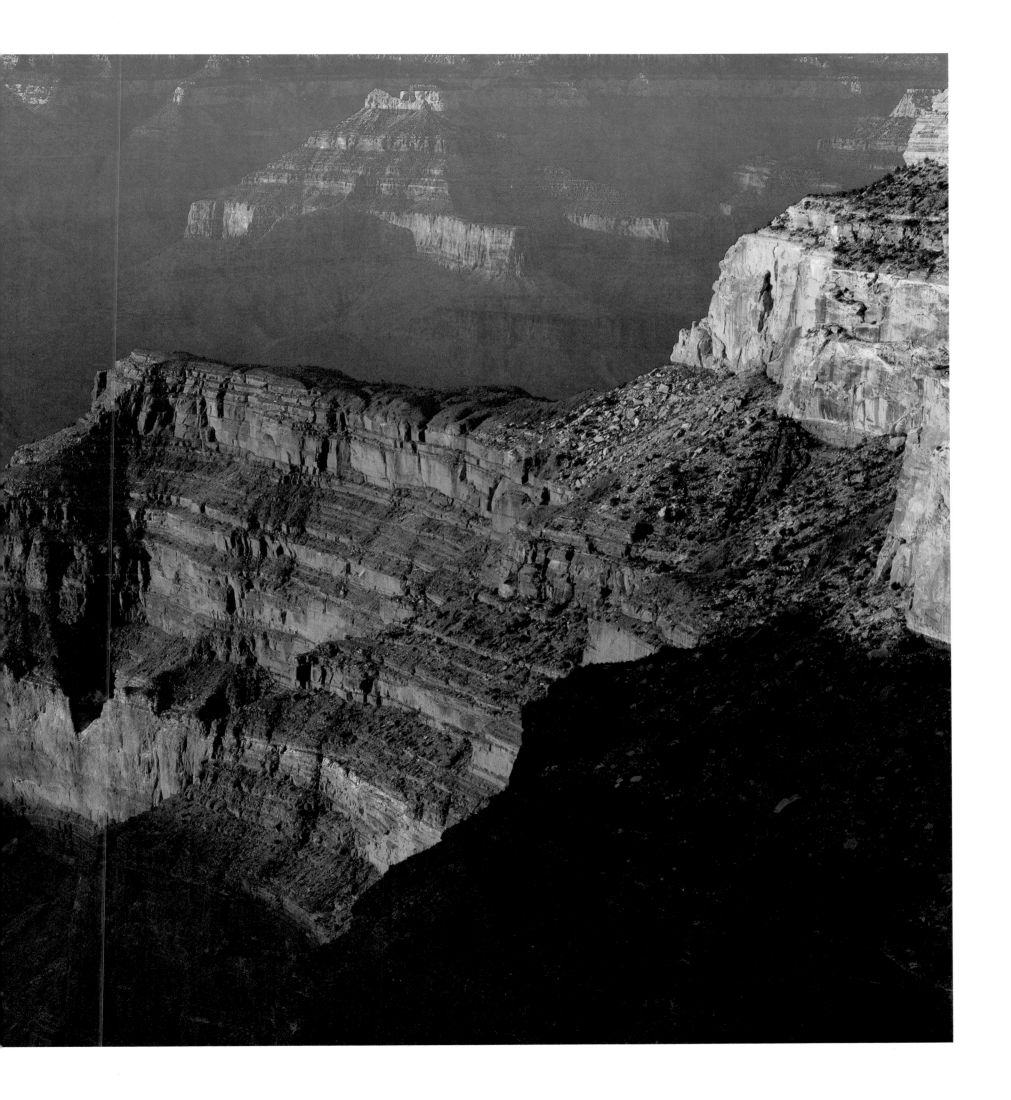

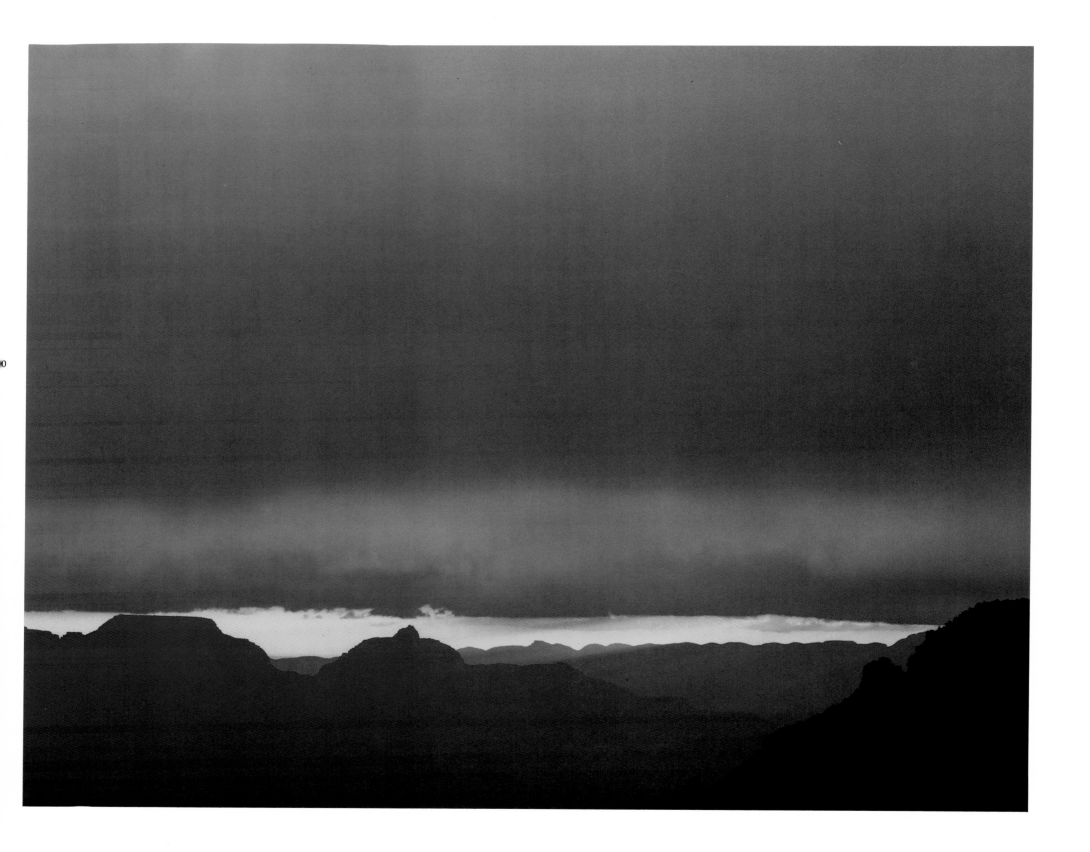

SUNRISE CLOUDS FROM MATHER POINT. For many, their first view of the Canyon is
from Mather Point, an overlook east of Grand Canyon Village. The view is a full 180
degrees and includes most of the Canyon's major features visible from the South Rim.
Here the Canyon lies deep in morning shadow while the silhouettes of Wotan's Throne
and Vishnu Temple are etched against a band of clear sky.

MATHER POINT. Limestone is easily dissolved by water, and limestone layers are often riddled with underground streams. This opening in the Kaibab Limestone of the South Rim was probably carved by water initially and later enlarged by wind as the rock around it eroded away. A sturdier form of limestone caps the rock, and once this is gone the weaker lower strata will quickly erode. The peaked formation in the distance is Isis Temple named for the ancient Egyptian goddess of fertility.

2

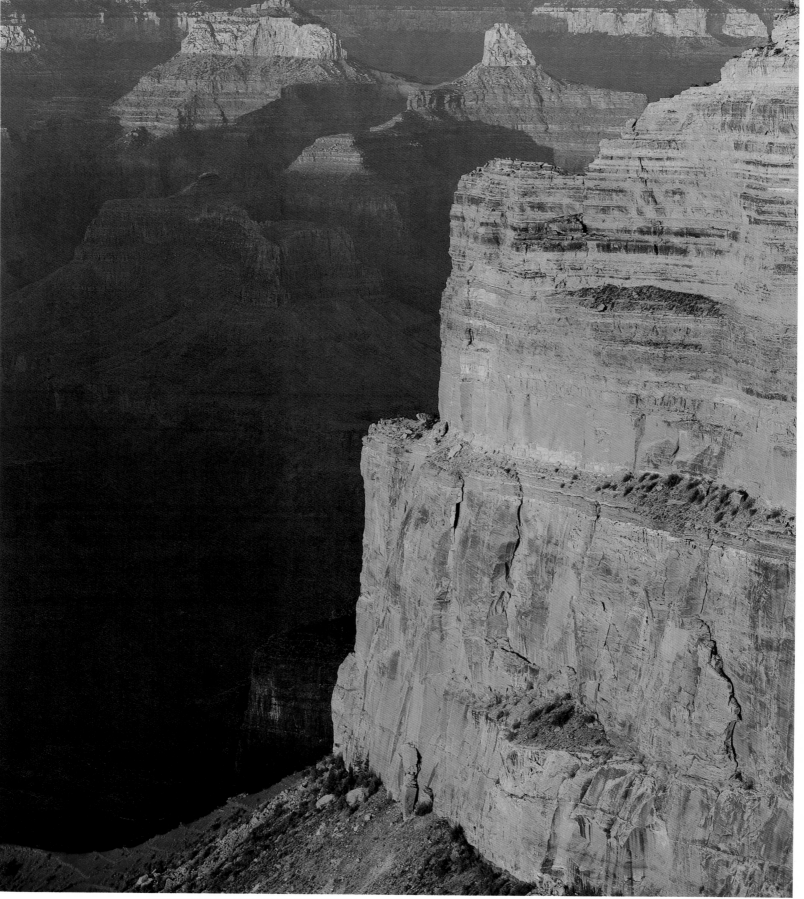

M OHAVE WALL. Just west of Grand Canyon Village on the West Rim Drive, the Canyon
drops off abruptly into the headwaters of Monument Creek in a gulf called the Abyss.
The east side of the Abyss is topped by the Great Mohave Wall, which takes on a rich
golden sheen in late afternoon light. Illuminated in the distance are the summits of
Brahma Temple and Zoroaster Temple.

A UTUMN SUNSET, WEST RIM. The moods and tones of the Grand Canyon are limitless. Timeless. Each place, each season, and each time of day hold their own hidden beauty. In the face of this great monument to the earth's creative powers, the concerns and worries of our own lives fall into a new perspective, and what is ageless in us is summoned in response.

4

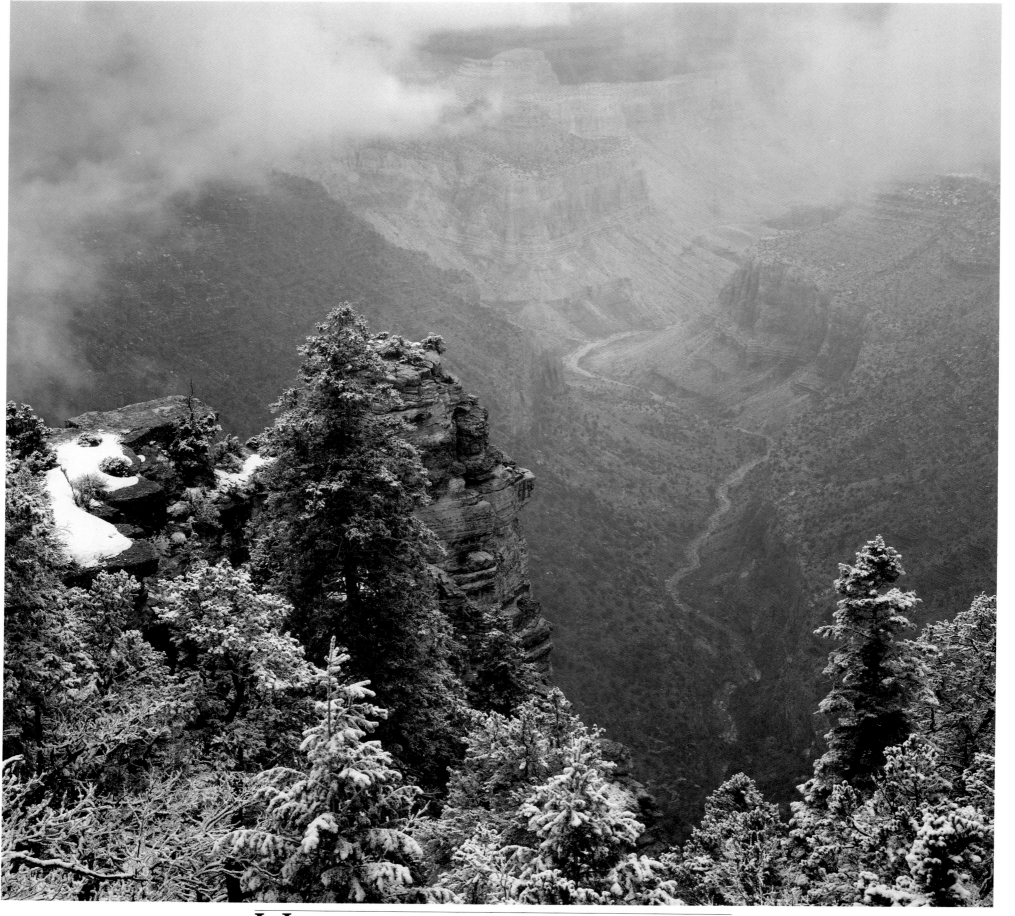

HANCE CREEK FROM SINKING SHIP OVERLOOK. A late winter snow has dusted the South Rim's trees while thousands of feet below, Hance Creek flows through a warm, near-desert climate. Douglas-firs indicate a cooler, moister microclimate that exists in sheltered coves just over the Canyon rim. Headwall topography provides shaded north-facing sites where winter snowpatches linger well into spring. Growing conditions here are similar to those found on the North Rim.

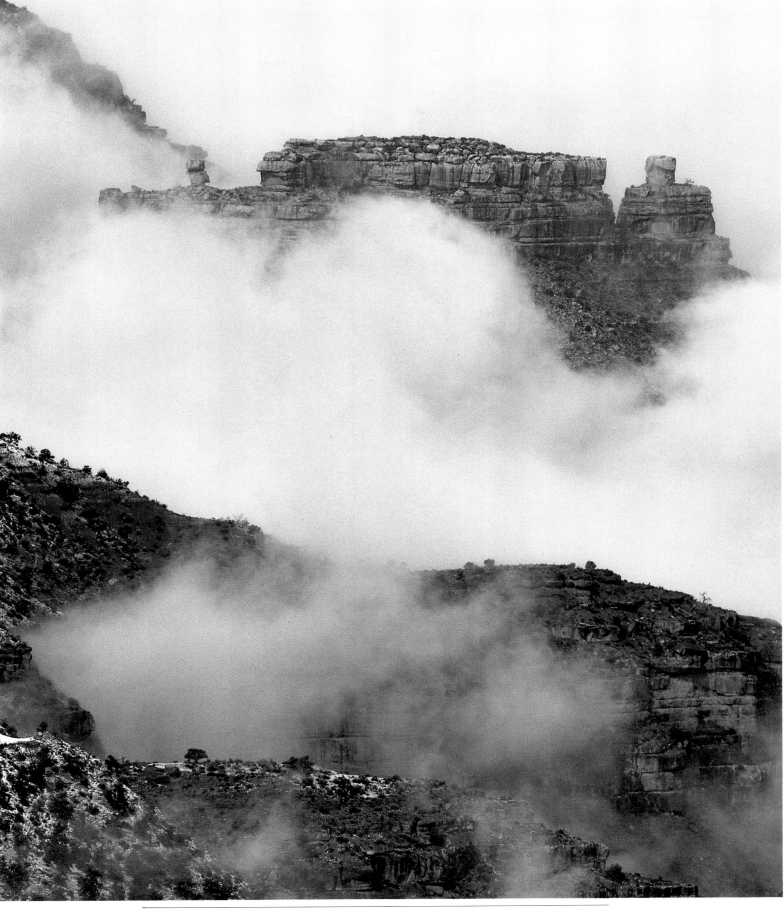

THE BATTLESHIP THROUGH LOW CLOUDS. When wet weather moves into the Canyon, clouds often come and go. Isolated formations sometimes seem to float on a sea of cloud, nearby ridges seem shrouded in faraway mists, and distant promontories loom up as if close enough to touch. From Three Mile House along Bright Angel Trail, the strata of the Battleship can be seen. The formation slips up along the Bright Angel Fault, one of the many vertical breaks in canyon rock where movement has occurred.

6

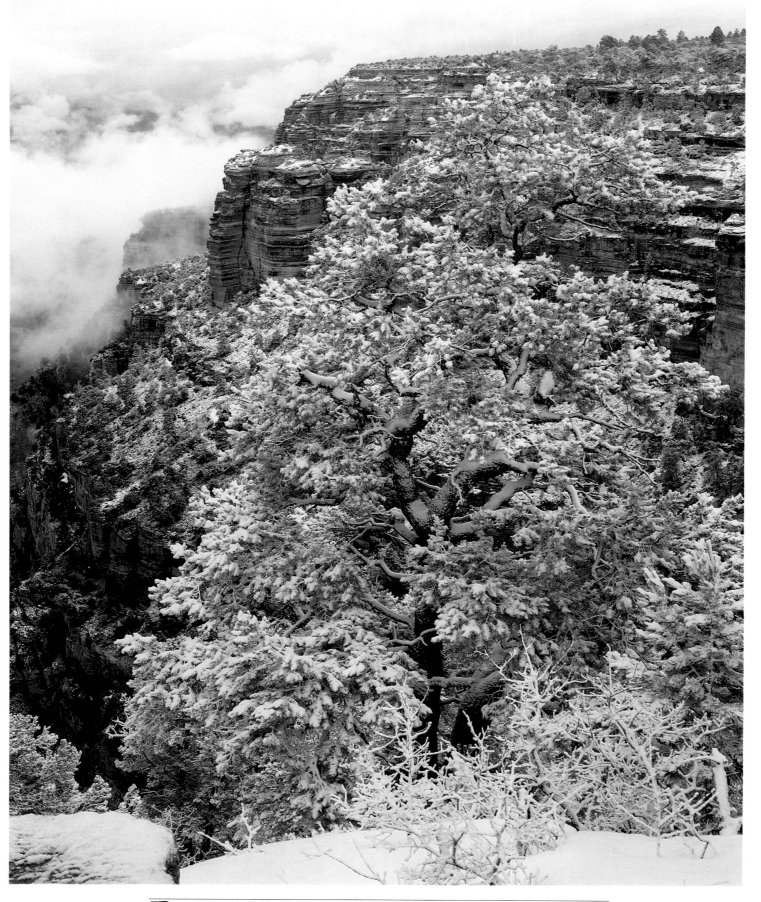

PINYON PINE AFTER A STORM. After winter storms on the South Rim, swirling clouds allow only bits and pieces of views. Clouds well up canyon walls and dissipate over the rim lending a misty, almost oriental mood to the scene. Pinyon pines along the rim often assume beautiful windblown shapes reminiscent of Japanese bonzai trees. These pines provide habitat and food for a wide range of birds and animals on the South Rim and also claim the more moderate slopes below the rim itself.

GAMBEL OAKS AND PONDEROSA PINE. The oak-pine transition forests of the South Rim provide a rich and varied wildlife habitat. In the fall, acorn woodpeckers gather their winter acorn supply from the oaks and store them in the hollows of ponderosa snags. Oaks also provide important browse for deer. Clusters of Gambel oaks often grow in the shelter of larger ponderosa pines where they are protected by shade and extra moisture. On the North Rim these trees occur in a narrow shrubby band just on and below the rim.

8

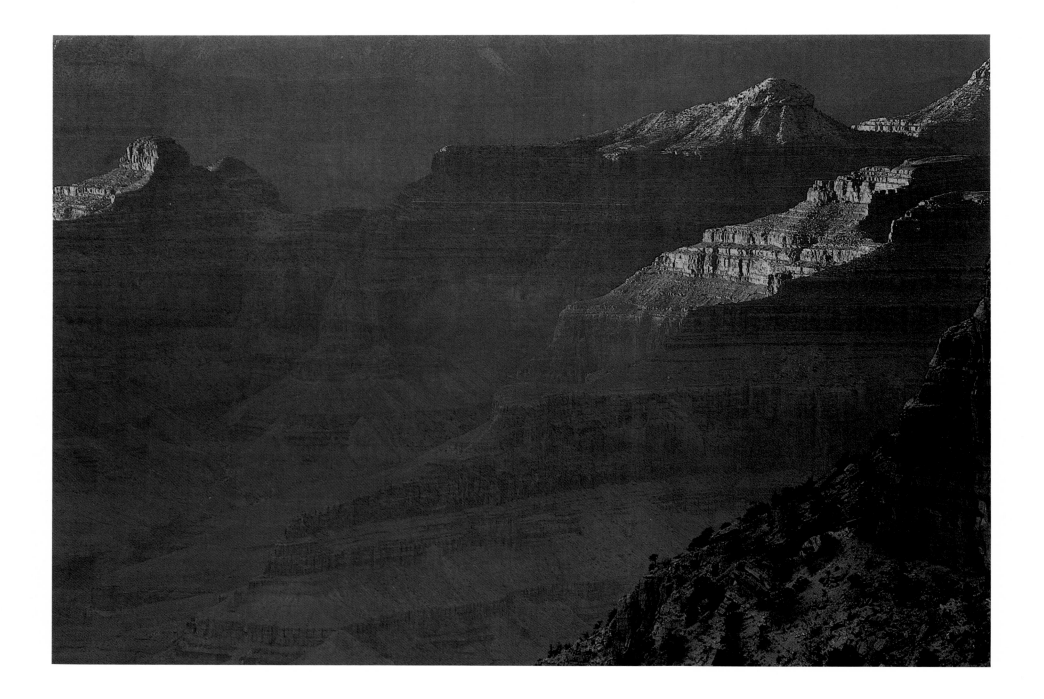

EVENING SHADOW, SOUTH RIM. As evening shadows rise up out of the inner canyon, there is a dramatic shift in mood. The low angle of light illuminates the many alcoves, nooks, and grottoes in the Canyon walls and throws the spur ridges and promontories into sharp relief. Gray-blue shadows climb up from the deep clefts of the Inner Gorge and soften the contours until only the uppermost formations remain sidelit from the west, drawing the sunset into a long crescendo.

SUNRISE, MATHER POINT. From almost anywhere along the South Rim at almost any time of day, the Canyon holds a special charm. For four thousand years humans have been a part of this remarkable landscape, and the Canyon sunrises continue to warm the faces and spirits of thousands of Canyon visitors today.

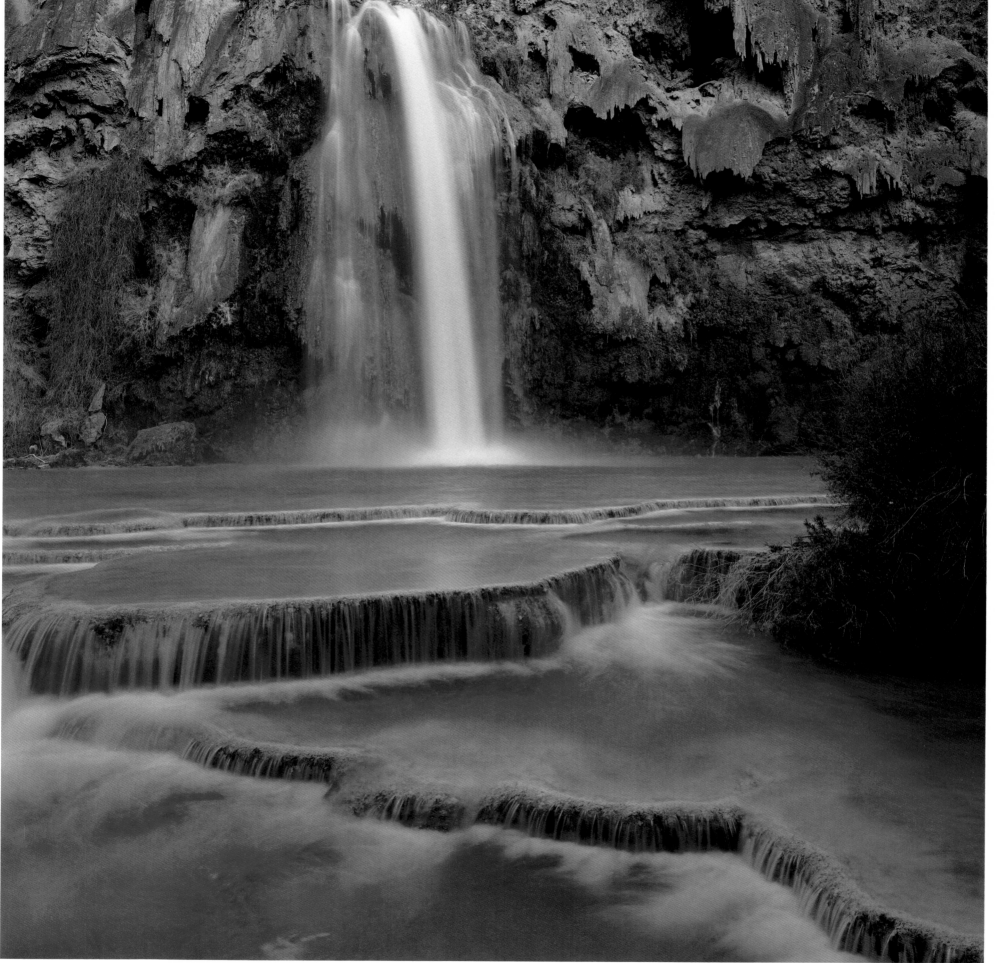

HAVASU FALLS

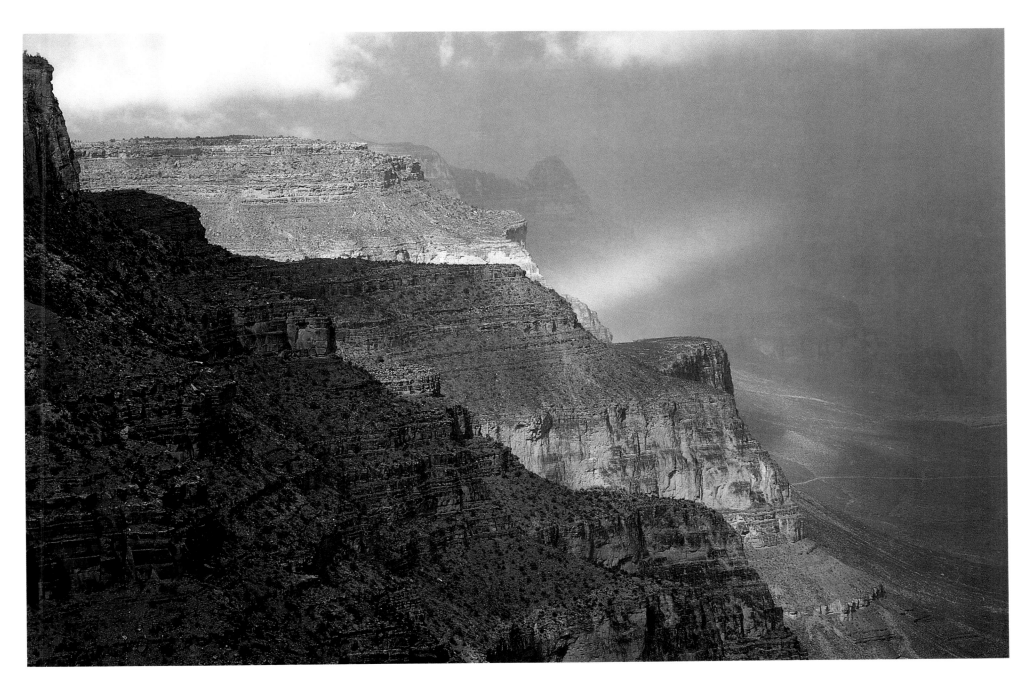

THE VIEW WEST FROM SOUTH KAIBAB TRAIL. The diversity of climate within the Canyon at any one time is remarkable. On the day this photograph was taken, a hailstorm had just swept across the South Rim. Four miles down the Kaibab Trail on the Tonto Platform it was a warm afternoon, and along the Colorado River in the Inner Gorge the temperature had reached 80 degrees. From the South Rim it's possible to look down through late winter snow to spring redbuds blooming on the Tonto Platform 3000 feet below, while the Inner Gorge simmers in the full heat of summer.

0

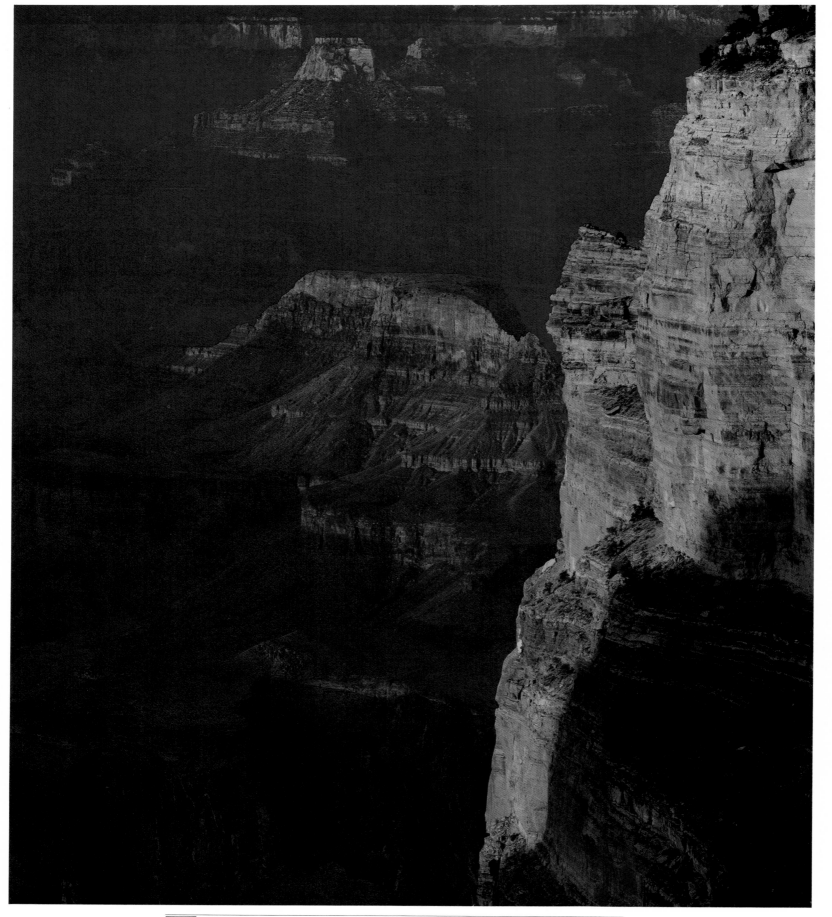

THE ABYSS AND MOHAVE WALL. The slopes of the Tonto Platform, seen here in the middle ground, are lit against the soft blue-gray shadows. The Bright Angel Shale that makes up the Tonto Platform erodes easily to wide, shallow slopes. Where possible, these arid slopes are covered predominantly by blackbrush, a low, shrubby vegetation, and are inhabited by rock squirrels, spotted skunks, prairie dogs, and blacktailed jack rabbits.

WITHIN CANYON WALLS
THE RIVER

Barely had the arched steel span of Navajo Bridge slipped behind the canyon walls, than our five small oar-powered rafts drifted calmly into the jagged flume of Badger Creek Rapid. Badger Creek was the first of over eighty named rapids between our put-in at Lee's Ferry and our take-out at Diamond Creek, 225 miles downriver. The sun dipped behind a bank of clouds, and our boatmen pointed the rafts toward the white water of the rapid.

The river had been running fast and high for the past few days. Faster water would mean more time in our 13-day trip to stop and explore the countless grottoes and side canyons. High water would give a smoother ride over most of the smaller rapids, like Badger Creek. At first this was a minor disappointment, but we consoled ourselves with the fact that the same high water would mean a much more exciting ride through the river's larger rapids. Soon, we were wringing out shirtsleeves and bailing icy water from the neoprene floor of the raft, and any disappointment we may have felt about the "smoother ride" through lesser rapids was quickly tossed overboard.

Diversity is usually a sign of a healthy functioning system, and there are many different ways of floating the Colorado, from huge motorized pontoon rafts to one-person kayaks.

Motor rigs move through the Canyon more quickly, and for those who are pressed for time, they offer a way to experience the inner canyon that otherwise would be unavailable. They also offer what is to some the benefit of providing a bit more security on the wilder rapids. Oar and paddle-powered rafts on the other hand, offer a slower, quieter, and more intimate involvement with the river, but require a high degree of skill and attention on the part of the boatmen. It was not unusual for our boatmen to pull in above a major rapid and spend an hour or more scouting its temper and habits—which can change hourly with varying water levels—before taking the rafts through.

The boatmen guiding our rafts down the river represented decades of cumulative experience in navigating white-water rivers from Alaska to Sumatra. Like all professionals, they took their work seriously. And like the rest of us who were entering the fabled white water of the Colorado's Grand Canyon for the first time, for them this trip was also an adventure, unique and unpredictable.

Above us, a flock of what seemed like hundreds of white-throated swifts dotted the narrow corridor of sky, wheeling and mating in long fluttering spirals and dives, and our first canyon wren echoed a welcoming song.

Lee's Ferry lies at the eastern edge of the Kaibab Plateau where the river enters Marble Canyon. Since the Colorado at this point cuts vertically into the upsloping strata that rise to form the plateau, we were able to see each successive formation of canyon rock lift out of the river as we traveled westward. Less than a mile below Lee's Ferry the marine limestones of the Kaibab Limestone made their appearance. This smooth grayish-white band would rise over 5000 feet to form the capstone of the Kaibab and Coconino plateaus, the roof of the Grand Canyon. Within a mile the Toroweap limestones followed, and soon the Permian desert sandstones of the Coconino also appeared. As we watched the sandstone cliff lift above us, followed by the older reddish shales of the Hermit Shale, the feeling was one of passage backward in time toward the very heart of the continent's crust. It was a feeling that that would prove true in a matter of days.

Early the next morning, we passed through a narrow slot in the canyon where a huge boulder lies in the center of the river. Logs and debris, swept downstream in the flood of 1957, still lingered high and dry on its top. Boulder Narrows signals the proximity of what boatmen have come to call the Roaring Twenties—a particularly turbulent stretch of river between miles 20 and 30 that averages one rapid per mile. In the high rushing water of the river, it was hang-on, duck, and bail in rapid-fire succession as the rafts climbed breaking waves, crested, and seemed to pause for a breath-held microsecond before plunging into deep troughs while boatmen strained at their oars to align the rafts for the next wave. This day, 24½ Mile Rapid seemed to possess a particular vengeance. Wave followed wave of frothing white water separated by deep troughs or holes. The rapid seemed like a mountain range of water, a miniature Himalaya uplifting and avalanching on all sides at once. Rapids are usually caused by large boulders and debris in the riverbed carried there by side canyons. Behind each boulder the river plunges down-

Sego Lily

ward to form a "hole" and each hole is in turn backed by an upwelling wall of water or "standing wave."

At the last roar of the Roaring Twenties, we tied the rafts into the narrow inlet of Silver Grotto and climbed a series of smoothly sculpted stair-step pools and water-worn troughs carved into the silvery gray limestone. Still, dark water lingered from the last heavy rain, and a small king snake flicked in a shallow pool. Pale walls rose above us like a chimney and cut far back into the canyonside. The sudden stillness and soft broken light of the grotto was a marked contrast to the excitement of the river below it.

Few of those traveling the Colorado River for the first time are fully prepared for the river's stunning silences and its ferocity, nor can they completely imagine the changing moods, the unique formations, and the overwhelming beauty of the side canyons. Some canyons remain unseen until they're upon you; others are visible from far away. But each has its own special presence, and together with the changing rhythms of the river, they make the inner gorges of the Grand Canyon one of the most diverse and beautiful of any waterway that graces our planet.

Past Silver Grotto, the canyon walls steepen markedly. John Wesley Powell bestowed the name Marble Canyon on this stretch for the beautifully swirled appearance of the rocks. Major Powell was the first to navigate the river through the length of the Grand Canyon in a heroic journey in 1869. A bend in the river around a smooth curving rock wall revealed the green oasis of Vasey's Paradise, also named by Powell for his friend, botanist G. W. Vasey. Here a garden of monkeyflowers, watercress, mosses, and ferns is watered by a falls that plunges from a cavern in the Redwall cliff and fans out into the lush growth. The contrast it forms with the arid canyon walls is dramatic.

The Redwall Limestone is riddled with caves, caverns, and miles of underground streams. Acidity of the water percolating through conifer forest soils, particularly along the North Rim, lends an added quarrying agent to the solutions that, over time, erode major channels along cracks in the rock.

An afternoon thunderstorm came up just a few miles above Saddle Canyon, and as we approached the canyon's mouth we could see a flash flood cascading over the redrock wall a short distance ahead. The muddy rust-red water plunged off a high ledge and waved in sheets and billows down the windy cliff wall. There was a falls a mile or two upstream that a certain nature photographer and I were anxious to see. As the storm began to taper off, we started over a rise and down along the warm muddy wash of the creek. Pat stopped to "take a closer look" at a beavertail cactus in bloom and began to set up his tripod. Knowing what that meant, and burdened with no more professional equipment than a notebook and pencil, I lost no time making my way upstream through a cool growth of box elders. Moist ledges and seeps were lined with moss and maidenhair fern, remarkably lush the farther upstream I hiked. As the canyon narrowed, ferns and columbines dipped and swayed in the downdraft and turbid water swirled noisily against the rocks. After stemming a narrow waterfall trough, wading the creek, and climbing the side of a boulder wedged in the gorge, I came to the grotto. In a narrow, steep-walled cleft in the rock, a falls spilled from a ledge about 40 feet above. The wind and spray sent waves rippling through the wall of hanging fern and moss that framed it. Normally just a trickle, today its tumult filled the grotto.

Thunder once more announced the resumption of the storm, and lin-

gering perhaps longer than I should have, I reluctantly began my way back down the canyon, well behind several others who evidently had a healthier respect for the quick temper of flash floods. As I waded out of the narrow portion of the canyon and prepared to make time, there was Pat, tripod over his shoulder, and ready to photograph. Having long admired this type of dedication to one's art, there was little to do but follow him back up the gorge—it was starting to rain in earnest now—and help with tripod and pack. As he composed, the thunder cracked and boomed and the sky darkened perceptibly. I don't remember how long we stood there in the rain, but it was with some relief that I heard that the light was less than perfect. Needless to say, we lost no time making our way back down the canyon, splashing across the rising water with thunder at our backs.

We camped that night near the Anasazi ruins on the wide delta at the foot of Nankoweap Canyon. That evening I hiked to the base of Barbenceta Butte, which offered a view up into the wild open country of Nankoweap Canyon as well as a considerable distance up and down the river. It is believed that the Anasazi seasonally occupied and farmed this gentle delta, as they did many others along the river. Seasonal flooding of the river deposited rich alluvial soils that were quickly planted with corn and beans. The ruins of the Anasazi dwellings, nearly 1000 years old, were across the creek along the top of a low ridge, allowing the lower, flatter lands to be used for crops. In the fading light of dusk, it was easy to imagine the wide area below planted with crops and crisscrossed with foot trails. Across the delta valley, at about the same elevation as I, tucked into a cleft in the cliffside, were the granaries, five small storage rooms that at one time were sealed to protect surplus crops from rodents and birds. They stand much as they did when last used by the Anasazi before they left the Canyon area never to return some 900 years ago. The reason they left is fairly certain—an extensive drought tipped their finely balanced agrarian economy over the edge of sustainability. But what their thoughts were, their feelings toward this vast and wondrous place in which they lived, we will never know.

To float the Colorado is to be carried along at the river's pace through vast dimensions of time and scale. One quickly loses track of date and days; time is the shifting of tones and textures along the miles of canyon walls, broken only by side canyons and rapids. Seven miles downriver, the canyon walls suddenly opened where the Little Colorado adds its waters to the Canyon. Quietly, without so much as a ripple, our rafts slipped past five snowy egrets on a flat rock at the water's edge. Conversations faded and our minds drifted back to a Cambrian world of warm shallow seas. Breathing was deep and slow. Then the faintest downstream murmur became apparent. It grew to an audible rushing sound, then a familiar roar. Suddenly the air temperature dropped and we grabbed the lines for another race through a wild jumble of cresting waves.

Again, the welcome rhythm of bailing warmed us after a cold dousing by the river. But the waves of Nevills Rapid were merely a warm-up. A mile or so later we entered Hance.

Haystacks of pounding water seemed to engulf the bobbing raft, but we managed to skate over them as they rose and crashed noisily at our sides. A wall of ten- to twelve-foot white water stood along the right side of the river (which we thankfully avoided), and some big frothing rooster tails whipped

AN OAR-POWERED RAFT ENTERS THE NOTORIOUS LAVA FALLS. The Colorado, even in its present regulated state, is an immensely powerful river. Where flash floods from side canyons have deposited boulders and debris in the river's channel, rapids occur. The Lava Falls Rapid, rated Class 10 on a scale of 1 to 10, is the result of remnant basalt deposits from volcanic activity that occurred about a million years ago. Today a "run" through Lava Falls is one of the most exciting on a river already more than generous with excitement.

the current near the end of the rapid. Our oarsmen handled it with a grace and skill that only pure adrenalin can fuel.

Three rapids in the Grand Canyon have reached mythic proportions. Hance is one. The other two lie below Phantom Ranch, several days apart. One is called Crystal, the other Lava Falls, and the tales that have grown up around them must constitute a substantial canon. Further, neither are rapids that respond graciously to high water. So it was not without some trepidation that we tied in above Crystal Rapid and climbed a rise to have a look. I thought it significant that no one said anything for a long time.

Before 1967, this notorious rapid was merely a riffle. That year a flash flood brought a load of boulders down Crystal Creek and piled them up in the river. Because the Glen Canyon Dam, built 15 miles upstream from Lee's Ferry, now restricts the periodic floodwaters that would normally work to dissipate the rapid, the rapid stays. For the time being at any rate. From the bouldery shore alongside the rapid, the holes and standing waves were awesome. There are five major waves, though from river level it appeared about ten times that number. The first, the Slate Creek Lateral, comes in from the left side at an angle. For a successful run, a boatman must begin cutting right almost before hitting this first wave. It is a matter of delicate timing: too soon and you'll go over the rocks, too late and you'll get pulled into five-waves worth of big trouble. The present high water served to quicken the pace, narrow the entrance, and make the initial move a bit more sticky. As we watched, waves thrashed, reared, and seemed to explode within themselves. And before each wave a swirling hole opened up—to where, no one seemed terribly interested in finding out. And the sound. There is no proper word for it. The soft thunderous roar began a half mile upriver from the rapid itself, and as we approached, it increased in volume and pitch, a growing crescendo that seemed to climax the moment we dropped off into the rapid.

In sharp contrast with the roar of rapids is the gentle water music of the side canyons. These change in character with each passing mile, and a single river trip allows one only the merest sampling.

At Elves Chasm, Royal Arch Creek has carved a descending series of waterfalls and cool, blue-green pools that seemed to increase in beauty and magic the higher I climbed. Maidenhair fern and moss line the falls as water spills from ledge to ledge in thin white ribbons. As I scrambled up ledges, boulders, and chimneys, the sandstone walls narrowed and waterfall followed waterfall in what seemed an endless progression. A gentle breeze wafted down the canyon and a golden columbine nodded on a ledge beside a plume of falling water, as if in homage to the water spirits that must surely dwell here. Around the fourth or fifth pool, the way becomes narrow and hikers find themselves stemming up between rock walls or carefully climbing the face of a boulder over a deep still pool. Above this, the chasm opens to a stair-step terrace of gently falling water and thick beds of red monkeyflowers, followed by a final curving headwall cliff where the creek trickles over a high ledge. A hundred feet above, the sandstone arch that gives the creek its name curves gracefully over the canyon. On a boulder below the falls, a tiny hummingbird nest thatched into a wisp of brush harbored miniscule chicks and a very tiny mother who dutifully swept in above me to tend to them.

Not all canyons treat visitors so lavishly. Stone Creek demands a hot, dry three-mile hike over rolling desert steppes before it unveils its pools and

falls in an exquisitely lit Redwall chasm. And the terraced pools behind Deer Creek Falls are attained only after a steep scramble up a trail through cliffs and a traverse along a shelf fifty feet above the surging waters of the creek. The rewards though—cool aqua-blue pools and splashing falls on a hot desert afternoon—far outweigh the energy expended to gain them.

The best known and what many consider to be the loveliest of the Grand Canyon's side canyons is Havasu, named for the Havasupai tribe that has dwelt there for centuries. To enter it from the river is to walk into the midst of a gardenlike canyon wound with wild grape and grasses, and shaded with low limbs of mesquite and catclaw. The creek descends in terraced, turquoise pools. The terrace ledges are formed of travertine, a mineral plentiful in Havasu waters, and the creek's color is derived from the mineral springs that feed it. A trail crisscrosses the creek, leading one through cool pools and along limestone ledges and boulders. Lizards skitter underfoot and ravens glide lazily upstream. At Beaver Falls, the trail climbs steeply up over parched dusty ledges of cactus and scrub, high above the green, breezy creek bottom. The contrast is remarkable. In a few hours a hiker will reach the windy cavern of Mooney Falls, where the creek takes a long vertical plunge from a high ledge curtained with travertine deposits to a deep blue pool. A windy spray billows out from the falling water. At the base of the falls the wind and noise are overpowering. An almost medieval chained stairway cut into the cliff wall provides passage to the campground and Havasu Village above.

It is difficult to imagine a more beautiful place to live than Havasu Canyon, and thousands make the long trek to visit here each year. But for me there was another canyon, nine miles upriver, on the far side of Mount Sinyala, the traditional Havasupai dwelling place of the dead. It holds the Havasupai family name of Matkatamiba.

It was already late in the day when our boats pulled into a narrow cleft in the canyon wall. Scrambling out over limestone ledges we worked our way into a fluted maze of converging striate walls that running water had carved into the smooth and fluid grace of a shell. The canyon wound up between high rock walls in pools and troughs like an intricate passageway, opening at last on a vast, walled amphitheater. It was as though we had passed through an elaborate mazelike entrance that led to the temple garden of a secretive earth goddess. Afternoon light slanted down across redrock walls and cast subtle hues among green stands of redbud, mesquite, and willow shrub that grew along the stream. The limestone floor, polished to a marble gray, descended in steps to the stream, while ferns, columbine, and monkeyflowers graced the lower walls and ledges.

The faint murmur of the water gave breath to the stillness, and a late afternoon breeze began to draft down the canyon. Behind this great hall, the canyon walls narrowed and steepened, and the flat gravelly wash of the canyon floor wound in labyrinthian curves and angles deep within these cathedral walls. The creek threaded its way through polished rocks and beds of sand with a soft whimsical gurgle and a splash.

By the time I followed the creek back to what I now called the Temple Garden, two Cooper's hawks were shaping circles across the small dome of sky, and a raven eyed me suspiciously from a sandy ledge. As I undid my shoes on a smooth stone step beside a pool, I noticed it was evening.

6

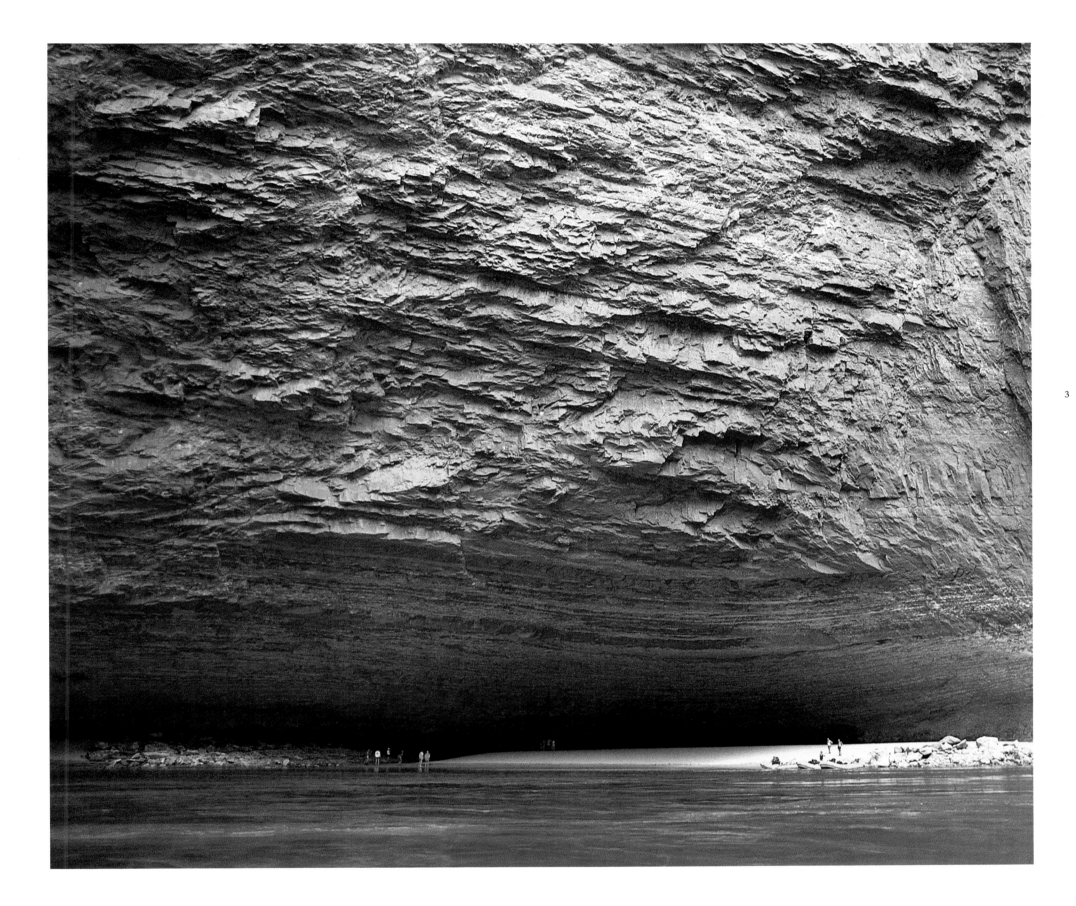

REDWALL CAVERN. On their historic exploration of the Colorado River by boat in 1869, Major John Wesley Powell and his party stopped to explore this immense cavern carved into the Redwall cliff of Marble Canyon. Over a century later, boaters still stop to explore the sandy-floored amphitheater to rest, swim, and stretch their legs. Many underground streams and rivers tunnel through the limestone to emerge in the inner canyon as falls and springs.

8

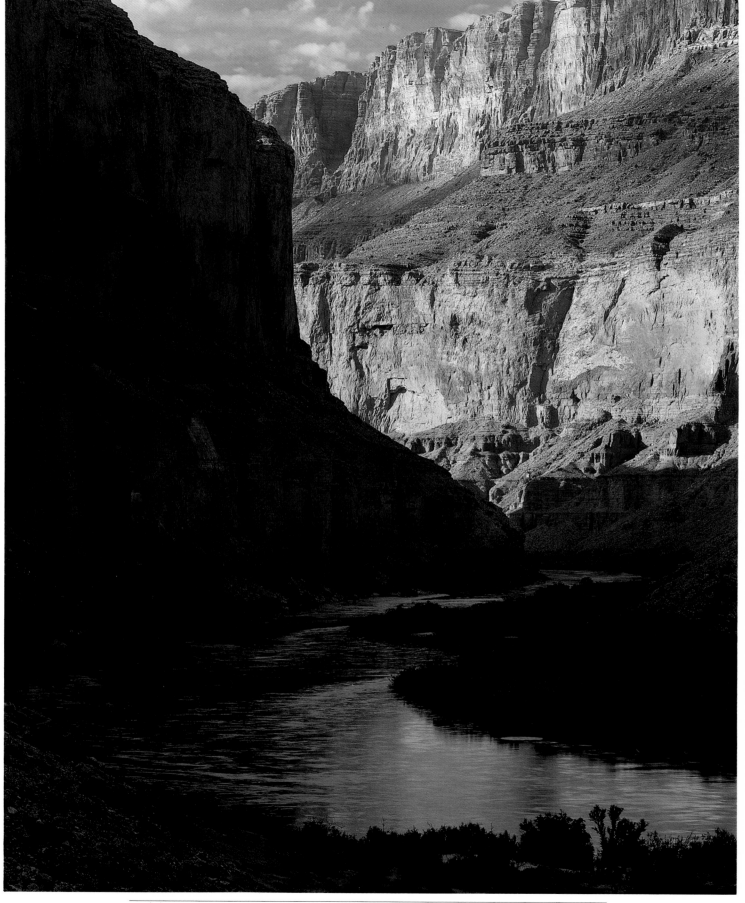

AFTERNOON LIGHT, COLORADO RIVER. Above Nankoweap Delta, the Colorado winds
slowly beneath the Redwall cliffs. The delta is one of over 2000 discovered agricultural
village sites for the Anasazi people, the "Ancient Ones." The Anasazi farmed the inner
canyon and the rims extensively from about A.D. 800 to 1200. All evidence of Anasazi
presence in the Canyon vanished after those 400 years, possibly because a change in
climate tipped the balance of their finely tuned farming economy.

3

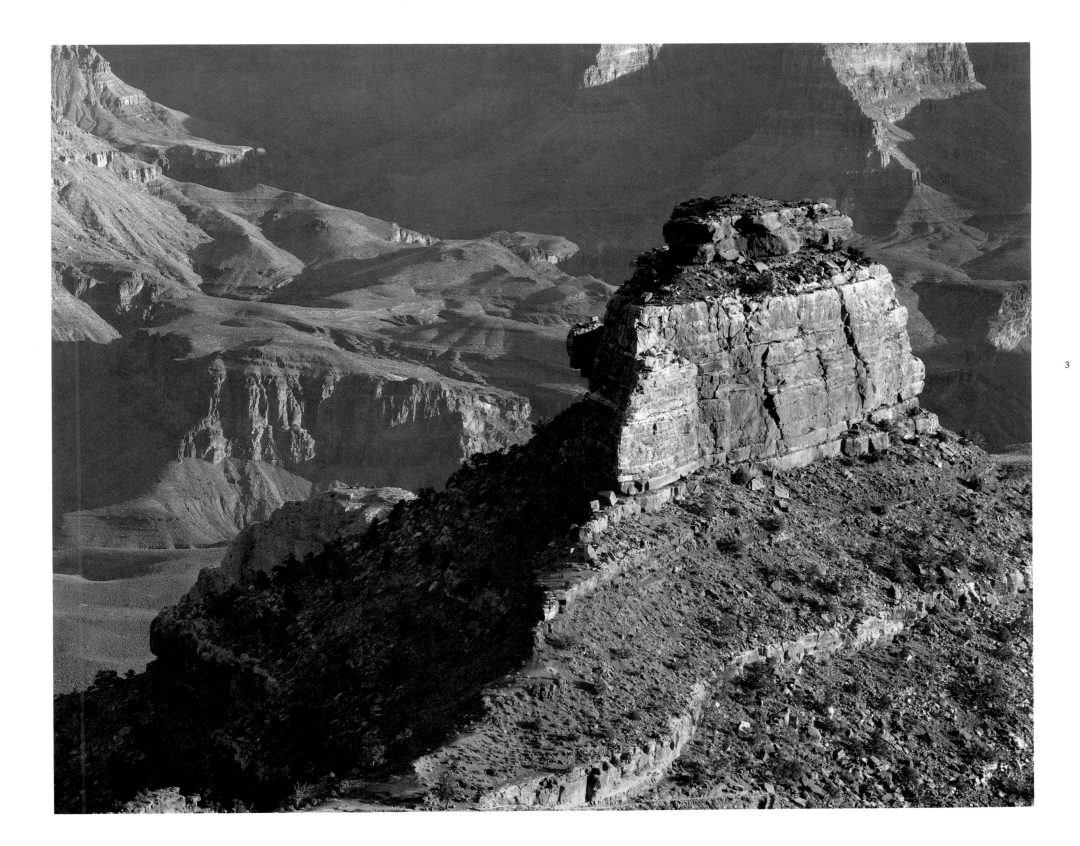

VIEW ACROSS O'NEILL BUTTE TOWARD THE TONTO PLATEAU. O'Neill Butte is a familiar landmark for those who hike the South Kaibab Trail into the inner canyon. The trail drops several thousand feet down Cedar Ridge and around O'Neill Butte and crosses the Tonto Trail. It then descends to the Colorado River bridge crossing near Phantom Ranch. This is one of the most popular trails in the park and is often the first leg of the route back to the South Rim via the Bright Angel Trail.

0

ROCKY GARDEN, HAVASU CANYON. The Grand Canyon is a landscape of contrasts. In an area generally known for its arid climate, microclimates also exist, like the moist niches along Havasu Creek where lush moss growing on rocks is accented by lichens and prickly-pear cacti. In other moist areas along this corridor, plant species usually associated with a wet environment are found—maidenhair fern, columbine, and yellow monkeyflowers.

4

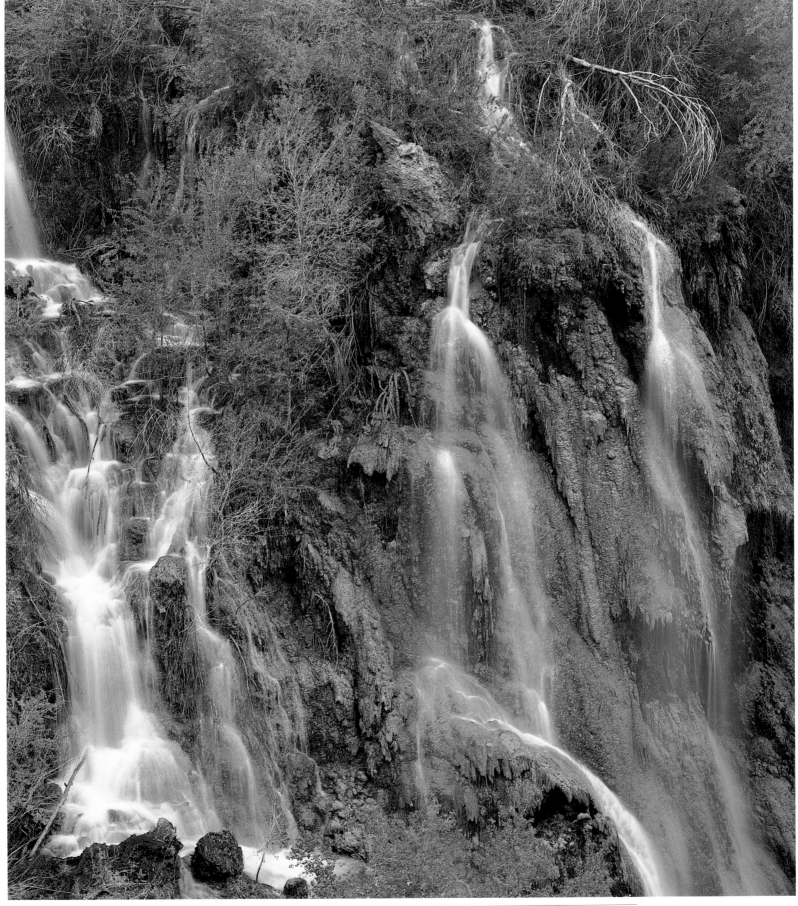

NAVAJO FALLS SIDEWASH, HAVASU CANYON. The hike through Havasu Canyon is superb. Within a short distance of Supai Village, Navajo Falls and its myriad small side channels are easily reached. If the angle of sunlight is just right, rainbows occur at the base of these channels and are worthy of a long, contemplative pause. Navajo is first in a series of gorgeous waterfalls in Havasu Creek's sinuous path to the Colorado River.

2

DEER CREEK. Deer Creek Falls is one of the few waterfalls in Grand Canyon that spills directly into the Colorado River. A short scramble up a steep slope leads to the grotto above the falls. Here Deer Creek has carved a graceful fluted canyon through striate layers of Tapeats Sandstone. The stream-sculptured forms of the park's side canyons are among the most beautiful anywhere, and are one of the many delights of floating the Colorado.

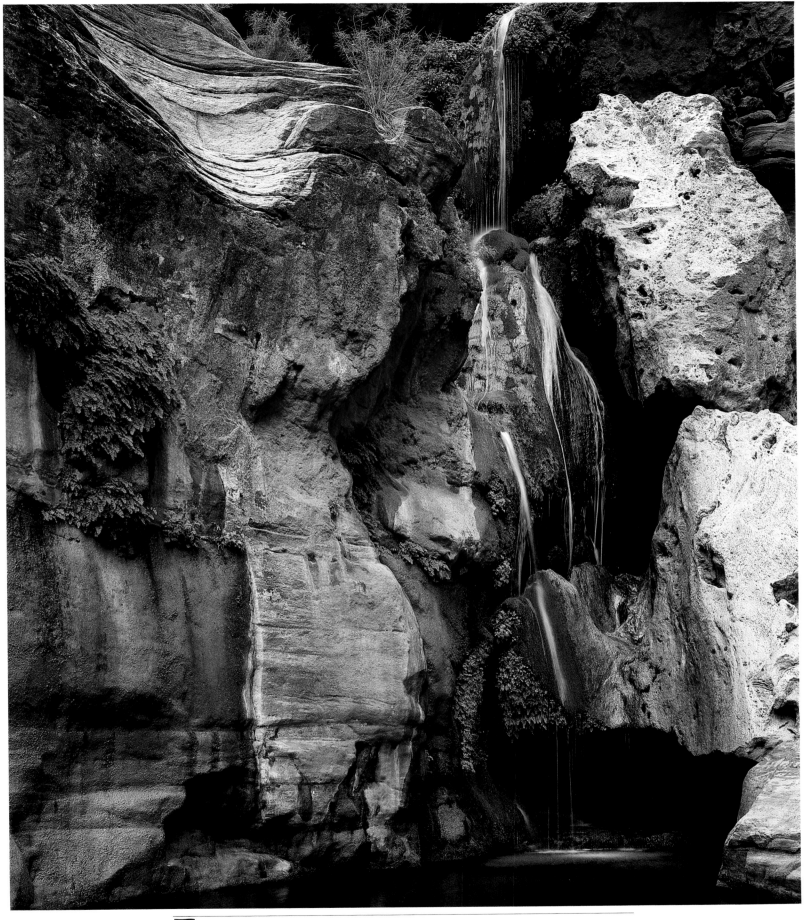

4

ELVES CHASM. One of the most popular of the side canyons is Elves Chasm. A wonderful series of waterfalls climbs back up the canyon in a system of small stairstep pools. Where the water threads its way down rock ledges, rich green gardens of life appear like miniature oases. Thick beds of moss and hanging clusters of maidenhair fern support occasional blooms of golden columbine. These waterfall gardens thrive in refreshing contrast to the stark desert heat of the Inner Gorge.

4

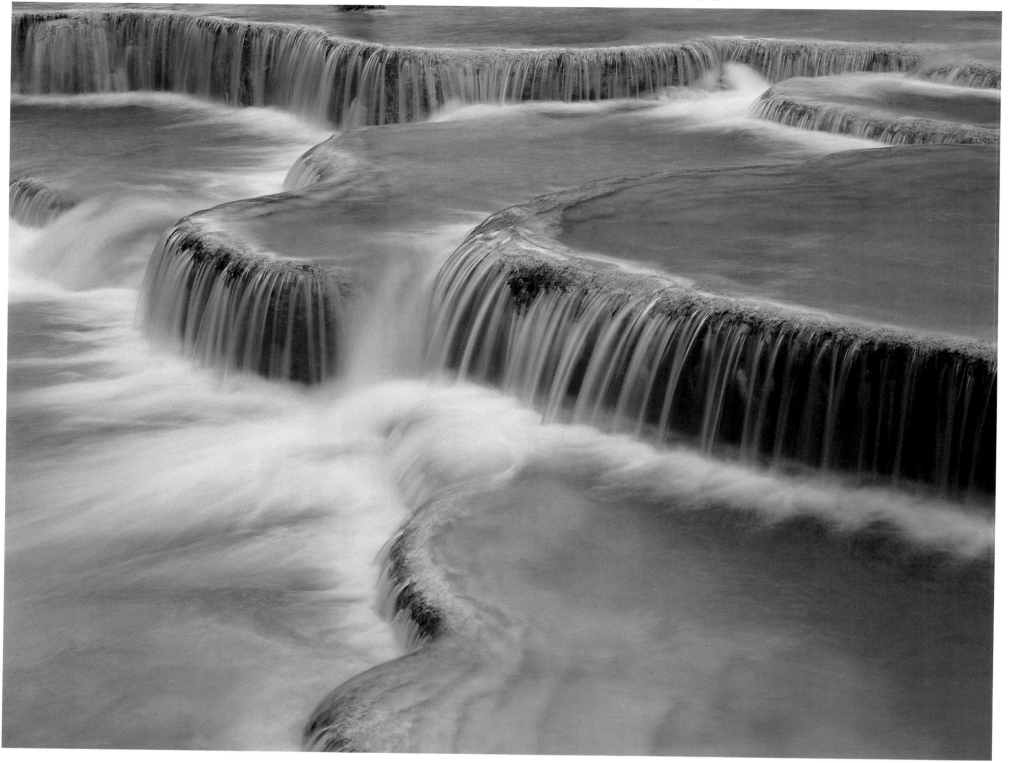

TRAVERTINE TERRACES BELOW HAVASU FALLS. Formed by deposition of travertine limestone, the beautiful creek terraces are continually changing as more limestone is being added. The Havasupai Indians are the "People of the Place that is Green," and their village is situated about one mile upstream. Downstream the water plunges over Mooney Falls on its short journey to the Colorado River.

HAVASU FALLS DURING SPRING. Havasu Falls and Canyon have been described with
every superlative imaginable. The paradise image is well deserved with its beautiful
blue-green water lined by large cottonwood trees. Access is by trail through Supai Village
from Hualapai Hilltop or by the canyon trail from the Colorado River.

6

R EDBUD BLOOMS IN EARLY SPRING AT INDIAN GARDENS. Along the Bright Angel Trail nearly five miles below the South Rim, Indian Gardens is somewhat of an oasis. It is possible to stand on the rim in several feet of snow early in spring and look down at the green shroud of vegetation at Indian Gardens. Redbuds usually bloom in April at this site and along other side streams and high water areas of the Colorado River.

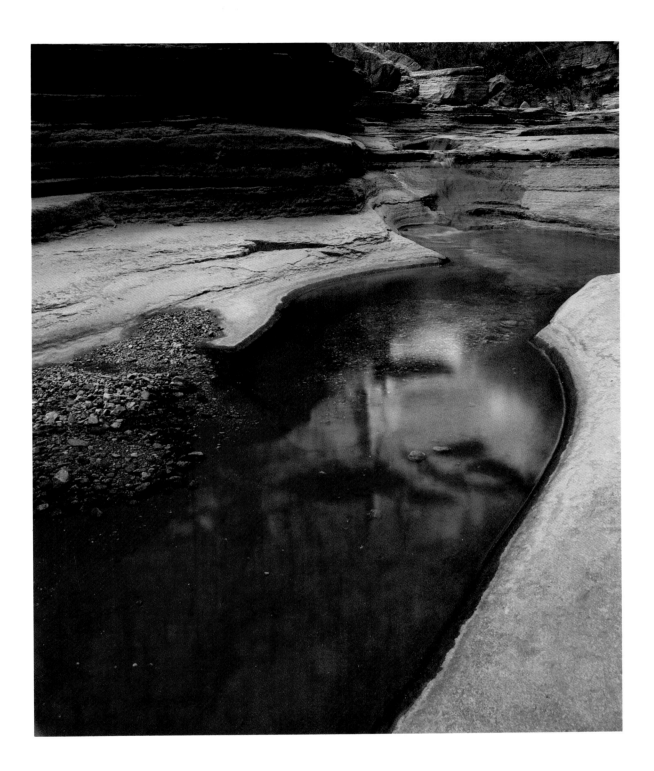

M ATKATAMIBA CANYON. Matkatamiba Canyon has become famous for its beautifully
curving striate limestone that has been exquisitely sculpted and smoothed by the creek. It
is bordered by a rich growth of redbud, acacia and mesquite, by scrub willows and ferns. A
few flowers dot the gravel bar. Steep Redwall cliffs line the canyon, giving a soft, coppery
light. Ravens flap from ledge to ledge and the soft trickling of the stream fills the canyon.

8

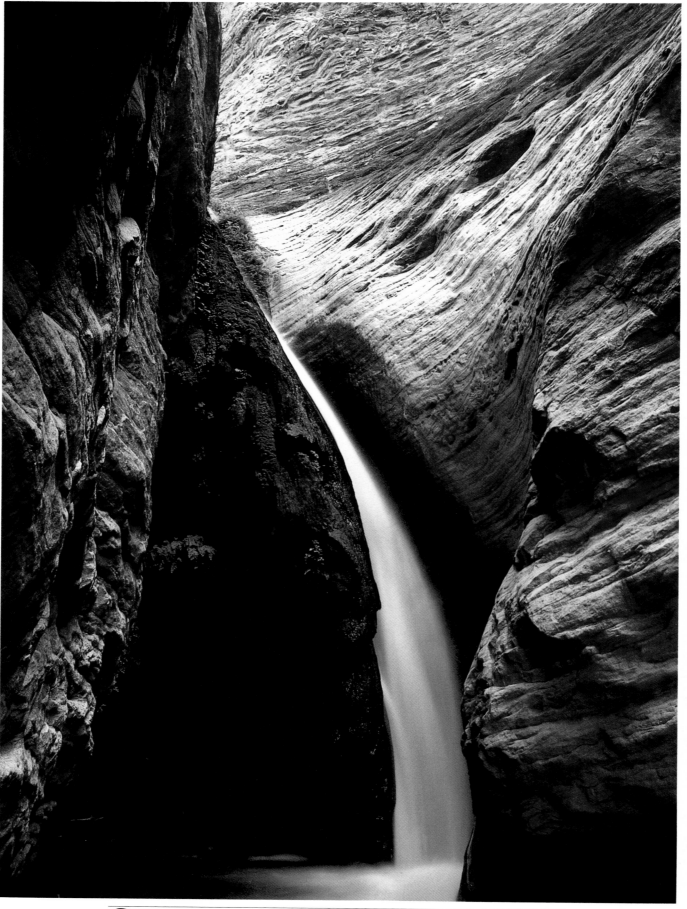

STONE CREEK FALLS. A hot three-mile hike back from the river through a typical lower Sonoran Desert plant community leads to a series of waterworn pools just below the Redwall cliff. The drainage, as it winds its way back into the Redwall, leads to this narrow grotto. Sunlight reflecting down from the oxide-stained limestone walls creates a magical setting.

4

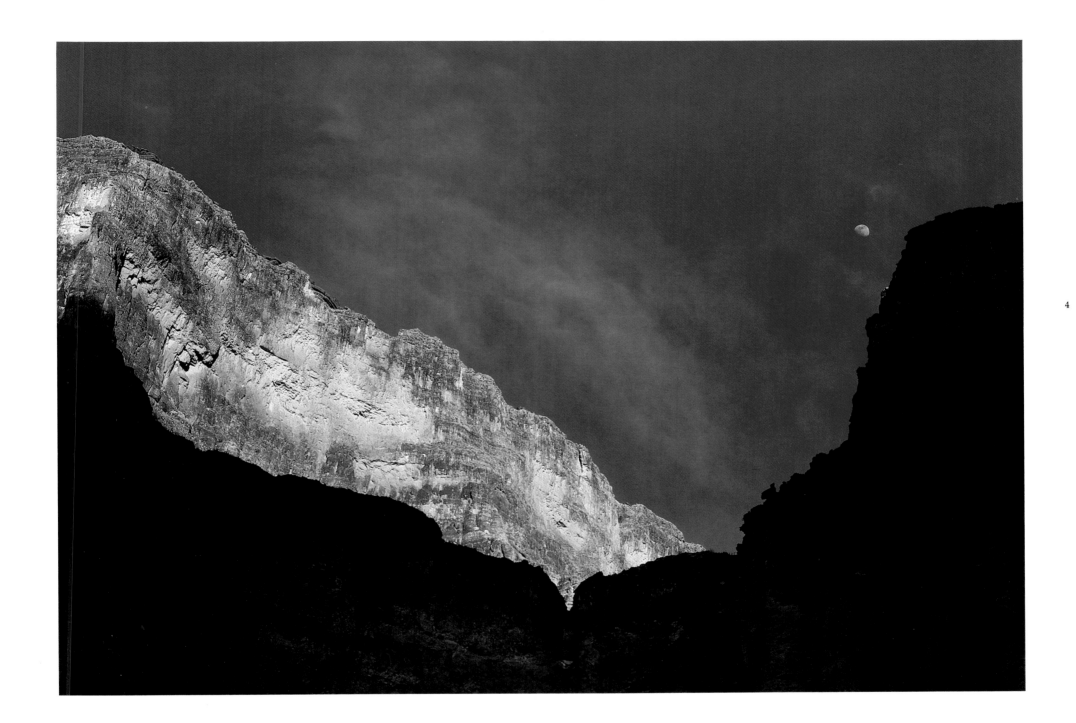

MOONRISE OVER THE INNER CANYON WALLS. To fully experience the Grand Canyon is to spend time along the Colorado River. The excitement of a white-water river trip, along with wilderness nights under the stars on a sandy beach, brings the immensity and age of the Canyon and our smallness, our youth, into greater relief. It is humbling to travel through a place where some of the rocks are two billion years old and where the canyon rim is 5000 feet overhead.

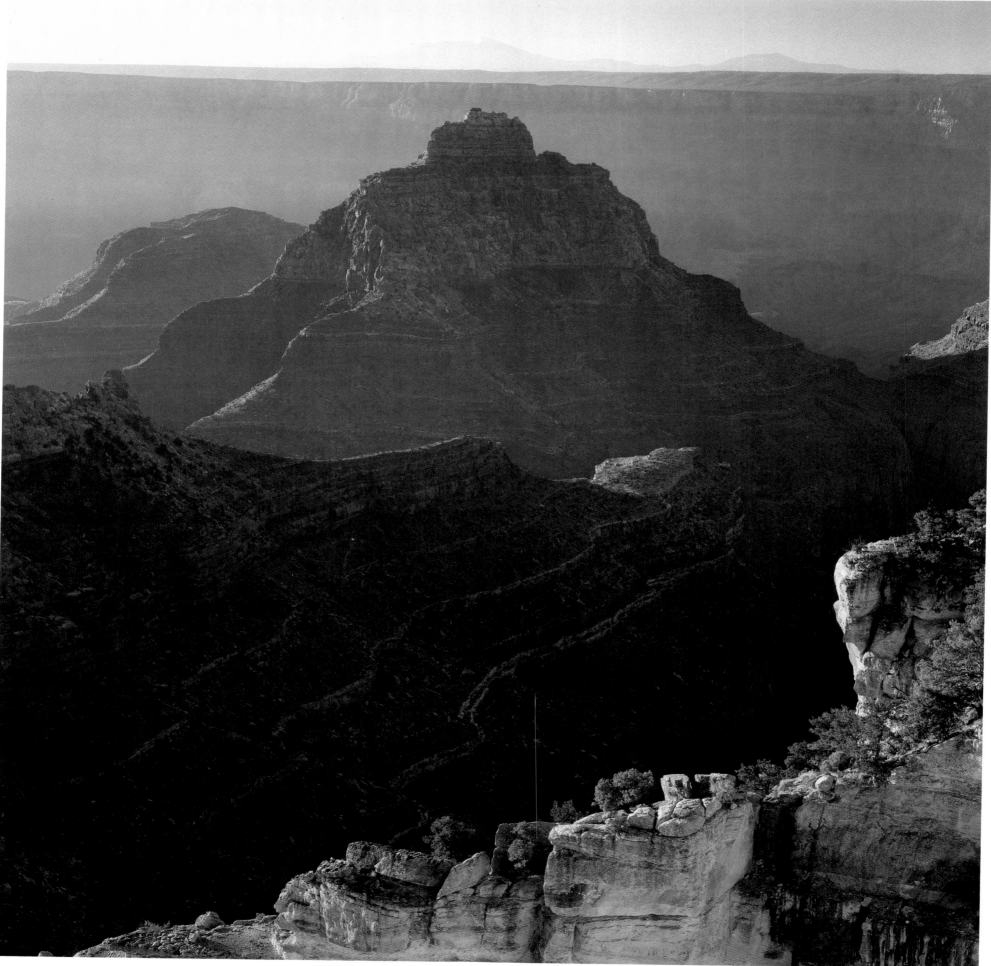

VISHNU TEMPLE AND SAN FRANCISCO PEAKS FROM CAPE ROYAL

MOUNTAIN ABOVE THE GULF
THE NORTH RIM

Each part of the Grand Canyon has a particular season or time when its magic is most alive. In early spring the tough, thorny cacti of the inner canyon bring forth exquisite blooms that fairly dazzle the desert landscape. Later, the flowering rock gardens of the South Rim lend a startling beauty to the upper cliffs and ledges. But the splendor of the North Rim forests reaches its climax in the fall.

By mid-September, the sky has become an intense blue. Wind patterns shift and begin to come from the northwest; summer haze disappears, and there's a refreshing crispness in the air. Mule deer are often seen now, feeding at the edges of meadows, and though the meadow wildflowers are gone—the goldenrods, harebells, lupines, and asters of summer—the ripened grasses subtly brighten the meadowlands with a rich amber hue.

In October, along the edges of meadows and scattered in groves throughout the North Rim's forests, the quaking aspens become lit with flamelike yellowy gold. In some parts of the North Rim whole hillsides shimmer, backlit by the sun, as the blue richness of the autumn sky gives shape and presence to each tree. Walking beneath aspens at this time is like entering caverns of golden light. Along roads and forest openings, the uppermost leaves will sometimes burn to a faint salmon color or later deepen to a rusty tan. Breezes rustle the leaves and the low sun lends a silvery sheen to the pale limbs and trunks.

Some years the golden days will last for weeks; other years a single storm will strip the groves of leaves within hours. But even then, single aspens or small groves sheltered in the depths of the North Rim's forests will glow like lamps among the dark blue-green conifers on into the first snows.

The North Rim differs in character from the South Rim in many ways. The South Rim presents a relatively continuous upper wall to the Canyon; however, the North Rim is dissected by amphitheaters, bays, and side canyons. These cut deeply into the plateau leaving long fingers of land that extend out over the Canyon as isolated points. The abundant rainfall and deep winter snows of the North Rim (as much as ten feet in some years) drain down the slopes of the Kaibab Plateau to feed the springs and long

Western Iris

tributary drainages, such as Bright Angel, Crystal, and Kanab creeks. The South Rim's position on the southern end of the plateau causes rainfall there to drain back to the south away from the Canyon. Consequently, the North Rim is characterized by long side canyons that have eroded back into the plateau to form the magnificent array of buttes, temples, and ridges that dominate the Canyon landscape north of the river.

Warm updrafts rising out of the Canyon combine with thin rocky soils to create an interesting microclimate along the edge of the North Rim. Though much higher than the South Rim, we find here a familiar band of pinyon-juniper forest. Cliffrose, serviceberry, fernbush, and mountain mahogany form the understory, along with such desert-type species as yucca, prickly pear, and Mormon tea. Below the rim, the pinyon-juniper stands descend the talus slopes and ledges as far as the top of the Redwall in places, and several buttes and temples are topped with them.

During the Pleistocene era when lower temperatures prevailed throughout North America, pine forests may have extended to the bottom of the Canyon in places. For the past 35,000 years however, the Canyon has acted as a barrier to the further migration of forests and forest-dependent wildlife from rim to rim. The resulting isolation has fostered a distinctive wildlife community on the North Rim. Its most notable member is the Kaibab squirrel, a rare color phase of the familiar tassle-eared Abert squirrel of the South Rim. The Kaibab squirrel sports a flashy white tail and confines itself, as does its southern cousin, to forests of ponderosa pine where it feeds on pine nuts and the inner bark layer of twigs. Other small mammals found on the North Rim but not the South include Nuttal's cottontail (a smaller version of the desert cottontail), Least and Uinta chipmunks, the conspicuous golden-mantled ground squirrel, red squirrels, long-tailed mice and voles, and bushy-tailed wood rats. These latter animals, though numerous, are mostly nocturnal and are seldom seen during daylight. The South Rim has its own community of specialized wildlife as well, and taken together, they comprise a diversity remarkable for the Colorado Plateau country. As we move back from Bright Angel Point, Cape Royal, or Point Sublime, we leave

the scrub and pinyon-juniper along the edge to enter the large open forests of ponderosa pine. Frequently, Gambel oak and New Mexican locust form the understory here, and in the fall these provide a subtle gradient of tans and yellows beneath the cinnamon-brown trunks of the pines. Extensive virgin ponderosa forests spread back along the Kaibab Plateau with exceptionally beautiful stands occurring on the Walhalla Plateau east of Bright Angel Canyon. To walk the old road beds that traverse this plateau is to be immersed in the smells and sounds of this tall and stately forest. Ponderosas are fire-dependent; they seed in after a burn, and mature stands are only maintained where periodic wildfires move through. Natural fires break down the forest litter into nutrient-rich ash layers and eliminate those species, such as white fir, that are not fire resistant. Where wildfire has been actively suppressed, fuel build-up and a crowded understory create dangerous conditions and a fire could easily destroy all. In order to return forests to a more natural condition, the park is presently intitating limited "control burns," as well as operating under a "let burn" policy, in which fire is allowed to resume its role in the ecologic balance of the forest.

With past suppression, stands of white and Douglas-fir and blue spruce have succeeded on some of the moister areas of the ponderosa forest. Today these comprise a forest type in themselves.

Above 8200 feet, increased moisture, deeper soils, and lower temperatures favor a closed canopy forest of spruce-fir. Engelmann spruce and sub-alpine fir, two northern species well-suited to heavy snows and extreme temperatures, become the dominant trees. Thick mosses and lichens, dead fallen trees, and deep decaying litter blanket the forest floor. Underbrush is sparse and red squirrels chatter loudly from the uppermost limbs. Clark's nutcrackers frequent these forests, and though seldom seen, the hermit thrush may be heard weaving its flutelike song through the shadowy woods. At night the trees are stirred by the wings of owls, and their hoots follow through the darkness.

Mule deer are common throughout the North Rim's forests, and coyotes can be seen hunting the open meadows in the early hours of dawn and at dusk. Cougars stalk the North Rim's deer herds, but they are reclusive hunters and sightings are rare.

In 1906, with the creation of a National Game Reserve on the Kaibab Plateau, a systematic elimination of predators was begun. At the time it was believed that this was the best way to protect deer populations. Within a few years, the native wolves were exterminated, hundreds to thousands of cougars, coyotes, and bobcats were trapped, and many eagles were killed. It was a world "made safe for ungulates," and within two decades as many as 1700 deer could be seen grazing a single meadow. Deer populations shot from 12,000 to over 100,000. The effects on forest, meadow, and brush communities were devastating. In the winter of 1924 the food supply failed and thousands of deer starved. Eighty to ninety percent of the forage was gone, and by 1930 the deer population had dwindled to about 20,000, many of them in poor condition. It was a lesson in wildlife ecology hard learned.

Since that time the predators (with the sad exception of the wolf) have made a recovery and numbers are now more in balance. Today our parks are managed to preserve the natural functions and interrelationships of wildlife populations and the native habitats on which they depend. To this end the park undertook a major removal of feral burros from the Canyon in the 1970s. In the few years since, sightings of desert bighorn sheep in the Canyon have increased substantially. Areas the burros had severely cropped are now reverting to more natural plant associations, and an elaborate network of "donkey trails" is slowly revegetating with desert scrub.

The Canyon's unique location in an area of transition between three of North America's four great desert regions also adds to its richness and diversity. Great Basin species such as big sagebrush, rabbitbrush, Mormon tea, and Indian ricegrass occur along elevation gradients within the park. In the inner canyon the flora represents an interesting mixture of more northern Mohave Desert species (blackbrush, bladder sage, and turpentine broom), as well as some Sonoran Desert species (catclaw acacia, ocotillo, and the yellow-flowered brittlebush). The frost-sensitive Sonoran species decrease upstream from the Grand Wash Cliffs as the Mohave influence becomes more prevalent. Traveling the river downstream from above Havasu Creek to the vicinity of Whitmore Wash, one might notice the sudden appearance of ocotillo, creosote bush, whipple yucca, coyote bush, and teddy bear cholla, while narrow-leaf yucca and Utah agave dissappear. Since construction of the Glen Canyon Dam and the elimination of the periodic seasonal floods that scoured the river's beaches, numerous exotic plant species, such as salt cedar and camel thorn, have colonized the shoreline and created a new riparian zone. The natural riparian zone, which existed higher up on the beaches, commonly

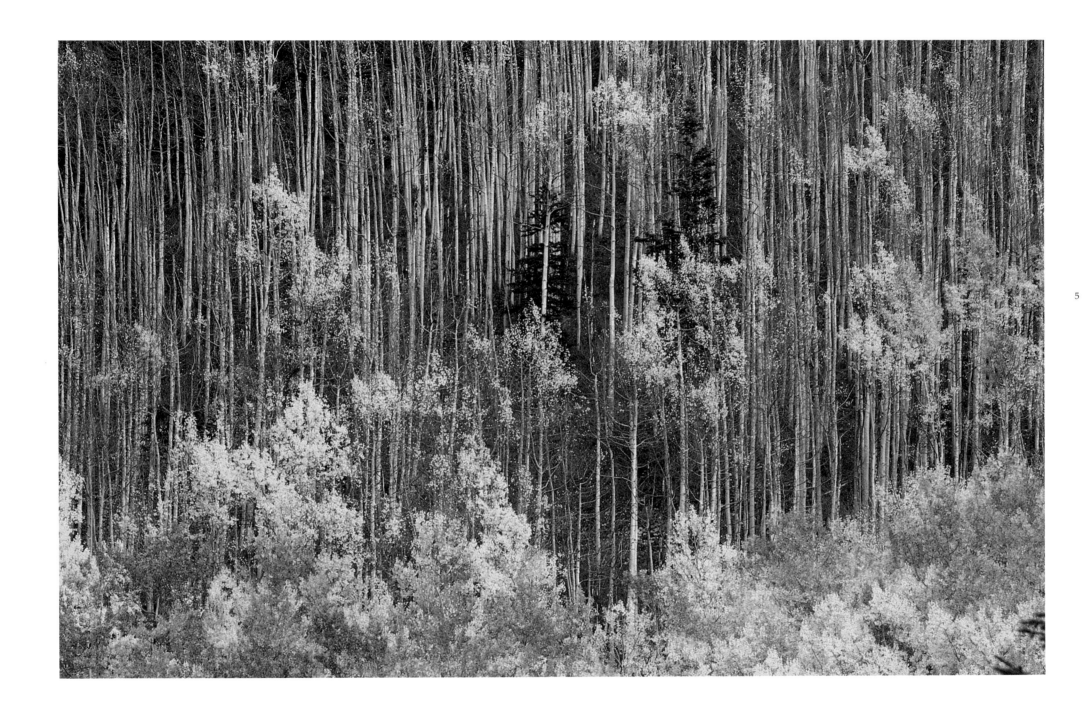

QUAKING ASPENS IN AUTUMN. The North Rim at 8000 to 9000 feet elevation exhibits colorful displays of aspen trees early in October. Their slender profiles, topped by feathery tufts of branches, form striking patterns. Ranging in color from brilliant yellow to reddish-salmon, aspen stands can be seen intermixed with ponderosa pine, Engelmann spruce, and white fir.

consisted of mesquite and acacia. Alongside springs and tributary streams, vegetation tends toward cottonwood, willow, and netleaf hackberry. Ringtail cats and spotted skunks haunt these communities, and spotted sandpipers, warblers, and grosbeaks provide flashes of color and song amid the stony canyon walls.

When Clarence Dutton explored the North Rim in 1880–81 as part of Powell's U.S. Geologic Survey, the marked diversity of the canyon country wasn't lost on him. "The whole summit is magnificently forest clad . . ." he wrote of the Kaibab Plateau after traveling from the Kanab Desert in 1880. "The other plateaus are formidable deserts; the Kaibab is a paradise." Dutton, like Powell before him, believed that the great chasm that lies beyond the rim was carved out by the downcutting of the Colorado River as the Kaibab and other plateaus uplifted, as it were, "around it." Later studies linked the plateau uplift with the Laramide Orogeny begun some 65 million years ago. More recently, the discovery of microfossils from Black Mesa in the shales of Muddy Creek Basin in the Lake Mead area indicates that the Colorado must have carved the Grand Canyon within the last six million years.

The process by which the Canyon was carved has been one of the great geologic questions of the past decades, and numerous theories have been put forth, studiously examined, and challenged or refuted by later findings. The problem was how to get a southwest-flowing Colorado to cut through a high uplifted plateau on its downward course to the Gulf of California.

One recent theory, which like most geologic theories is a refinement of older work, offers a fascinating explanation. Briefly, this theory describes the ancestral Colorado as a slow stream draining the western Rockies through a series of ponded basins to the north. Most of the runoff from the Rockies was trapped in these basins and evaporated. The ancestral river flowed south around the Kaibab Plateau through a notch formed by the Chocolate Cliffs and the top of the plateau. The river, weak and sluggish, was not cutting down into the top of the Kaibab Limestone at this time, but rather wearing away the softer sediments that then capped it while gradually "migrating" south (downhill) off the plateau. Once around it, the river flowed out northwest to dry up in a desert basin probably located in what is now Nevada.

To the west, earth movements associated with the Basin and Range faulting had formed the lower Grand Wash Cliffs and the Mogollon Rim. A small drainage flowed out from there and emptied into the Muddy Creek Basin in the present area of Lake Mead. Around this time the ancestral lower Colorado (a different river) was cutting back northward with headward erosion from the Gulf of California and incorporating a series of inland drainage basins. Eventually it reached the Muddy Creek Basin. The dropoff now created from the lower Grand Wash Cliffs, and increased runoff gave the lower Colorado some cutting power. It soon began to incise a shallow canyon and extend its headwaters back toward the major north–south trending fracture of the Hurricane Fault. The lower river was quickly able to take advantage of this weakness and extend its canyon north from the present area of Diamond Creek to Whitmore Wash. From there the river cut back along several northeast-trending faults and extended its headwaters east. As it eroded into the plateau, it picked up several tributary drainages, steepened its gradient, and increased in volume and cutting power.

By this time the upper Colorado had migrated far enough down off the Kaibab Plateau to encounter the Grandview Monocline. This little wrinkle in the limestone at the southern end of the plateau effectively trapped the upper river and locked it into its course. It could no longer sidle on down the hill avoiding the tough limestone; it now had nowhere to erode but down. Also at about this time, the upper Colorado had filled in its northerly drainage basins with sediments and now carried the full flow from the western Rockies. Once the lower river chewed its way east through a low spot in the Supai Monocline, it was only a matter of time before it "captured" the upper river in the Kanab Creek area and diverted its flow out to the Gulf of California. This occurred some five to six million years ago. With its greatly increased flow, steeper gradient, and the tremendous amount of rock, silt, and gravel debris it carried, the Colorado was easily able to carry out its monumental work, the carving of the Grand Canyon, a masterpiece of erosive sculpture unequaled on any of the continents.

Of the Chocolate Cliffs that hemmed in the ancestral Colorado for so long on the south, all that remains are the remnants of Cedar Mountain and Red Butte. Recent volcanic activity in the Toroweap area of the North Rim resulted in lava flows that served to dam the river for a short time before the basalt was whisked away like leaves. The great carver, the Colorado, can be momentarily slowed, but its erosive work will continue all but unabated. You might say it has time on its side—vast quantities of time, and no schedules to meet.

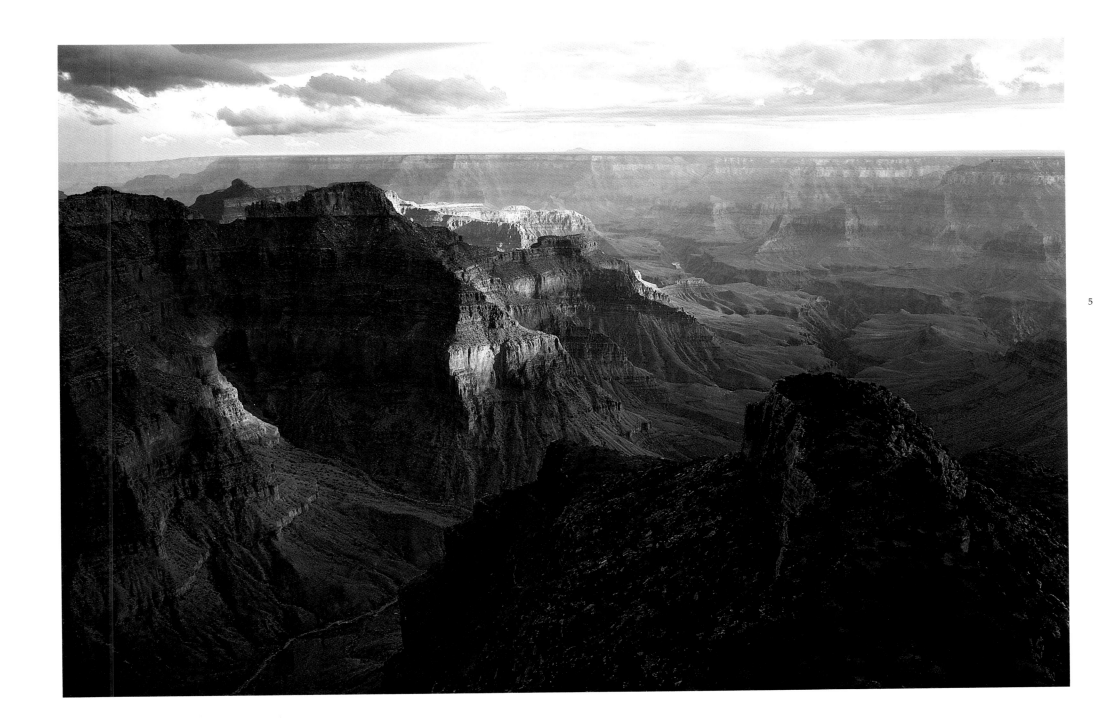

POINT SUBLIME AND THE TUNA CREEK DRAINAGE. In 1880 geologist Clarence Dutton and artist W. H. Holmes spent much time studying and interpreting the Canyon's geologic history from Point Sublime. The resulting monograph, *A Tertiary History of the Grand Canyon District*, remains a classic in American nature writing. Dutton described the panorama from Point Sublime as an "abrupt disclosure of the spectacle." To him the scenery far surpassed "in grandeur and nobility anything else of the kind in the region."

6

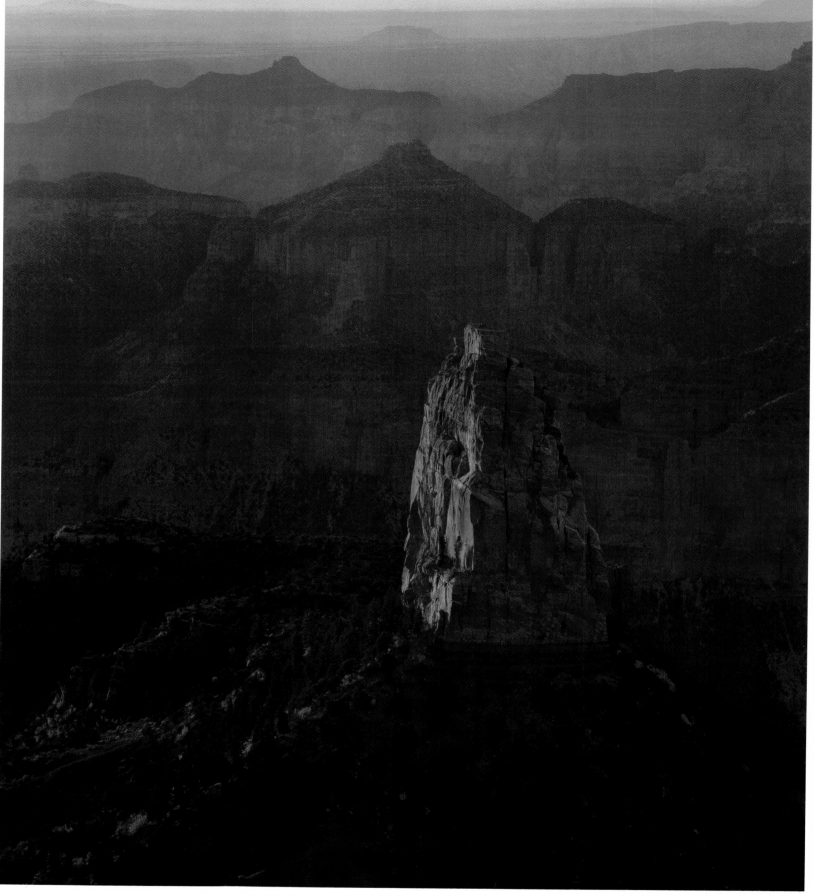

MOUNT HAYDEN IN MORNING LIGHT FROM POINT IMPERIAL. Point Imperial at 8803 feet is one of the highest points on the North Rim. From it one can watch as early morning light illuminates the cap of Coconino Sandstone on Mount Hayden, a formation named after Charles Hayden. Hayden came to Arizona in 1857 and later established Hayden's Ferry in the area that is now Tempe.

FROM POINT SUBLIME SOUTH ACROSS SAGITTARIUS RIDGE. Morning light accentuates the forms of Castor Temple, Paiute and Walapai points to the south. Clarence Dutton described the view from Point Sublime: "In the early morning its mood and subjective influences are usually calmer and more full of repose than at other times, but as the sun rises higher the whole scene is so changed that we cannot recall our first impressions. Every passing cloud, every change in the position of the sun, recasts the whole."

8

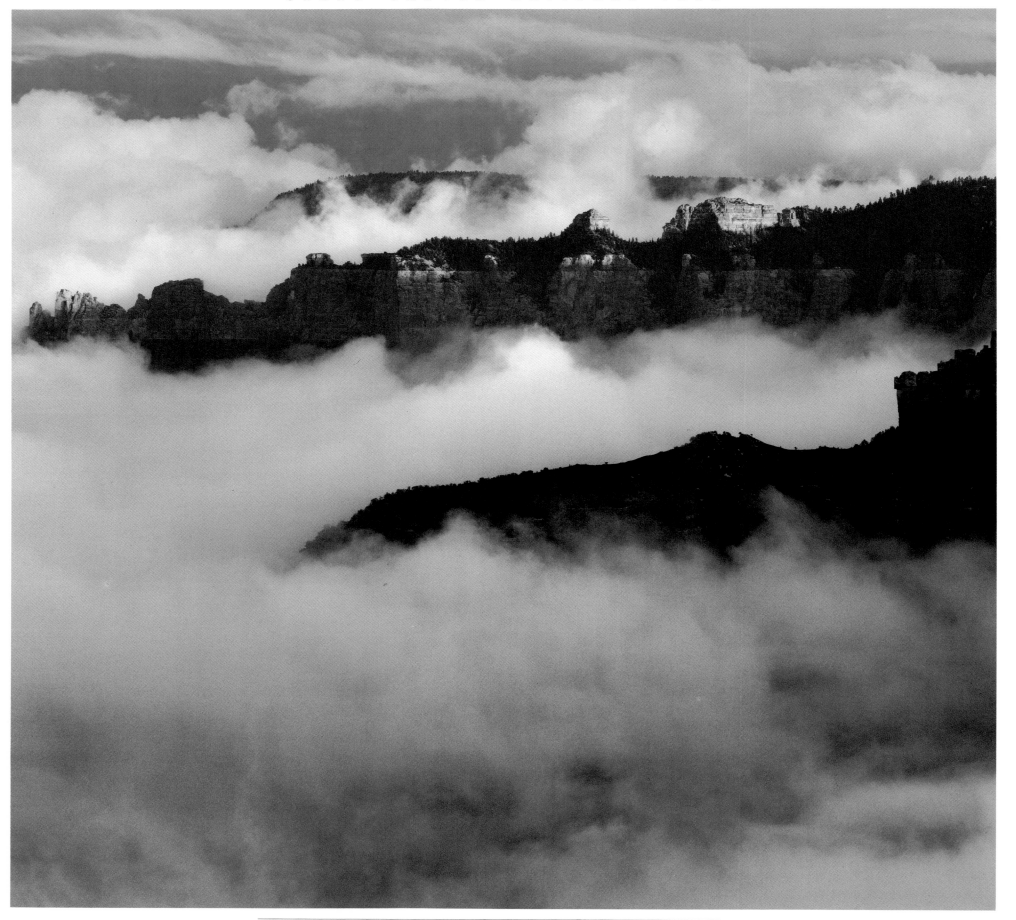

E VENING VIEW FROM POINT IMPERIAL. As clouds drift in among the side canyons, the buttes and ridges to the south appear as isolated islands. Siegfried Pyre and the Cape Final rise above, and spots of exposed rock catch the last rays of evening light. The south sloping aspect of the Kaibab Plateau results in the longer eroded side canyons and ridges that characterize the North Rim.

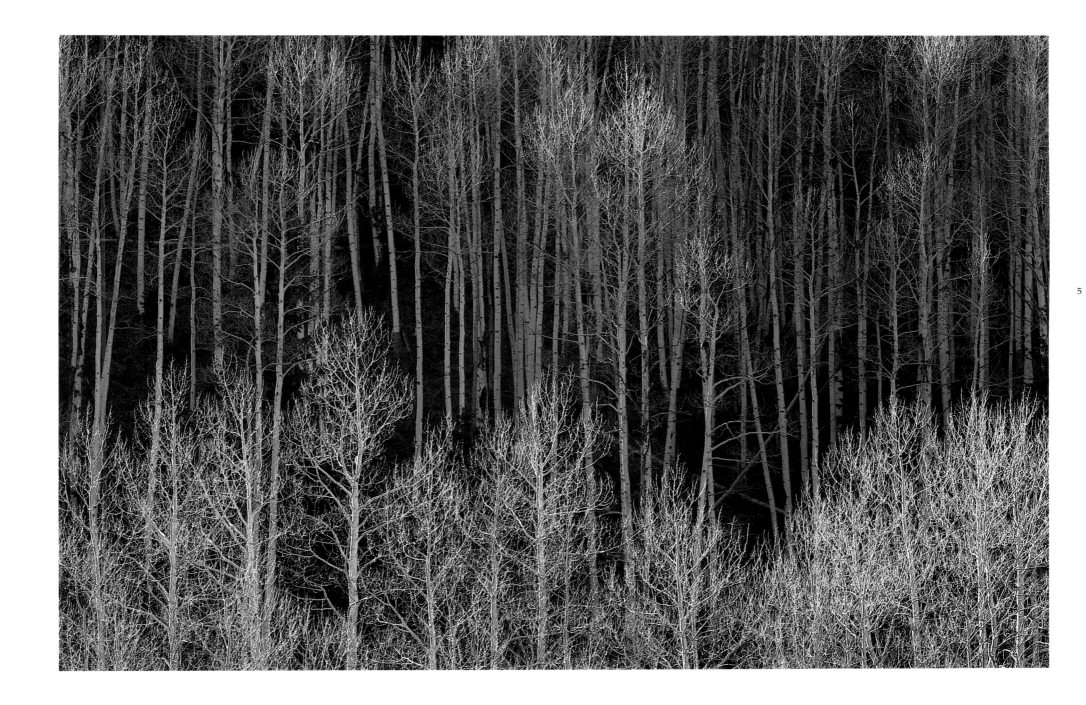

ASPEN GROVE NEAR NEAL SPRING. The first storm of autumn strips the aspen trees of their colorful foliage. Within a few days the hillsides are transformed from a patchwork of warm golden colors to a monochromatic interplay of light gray forms against a shadowed background. This cyclic ritual nurtures the soils with a mulch of decomposing leaves as the trees go into winter dormancy.

0

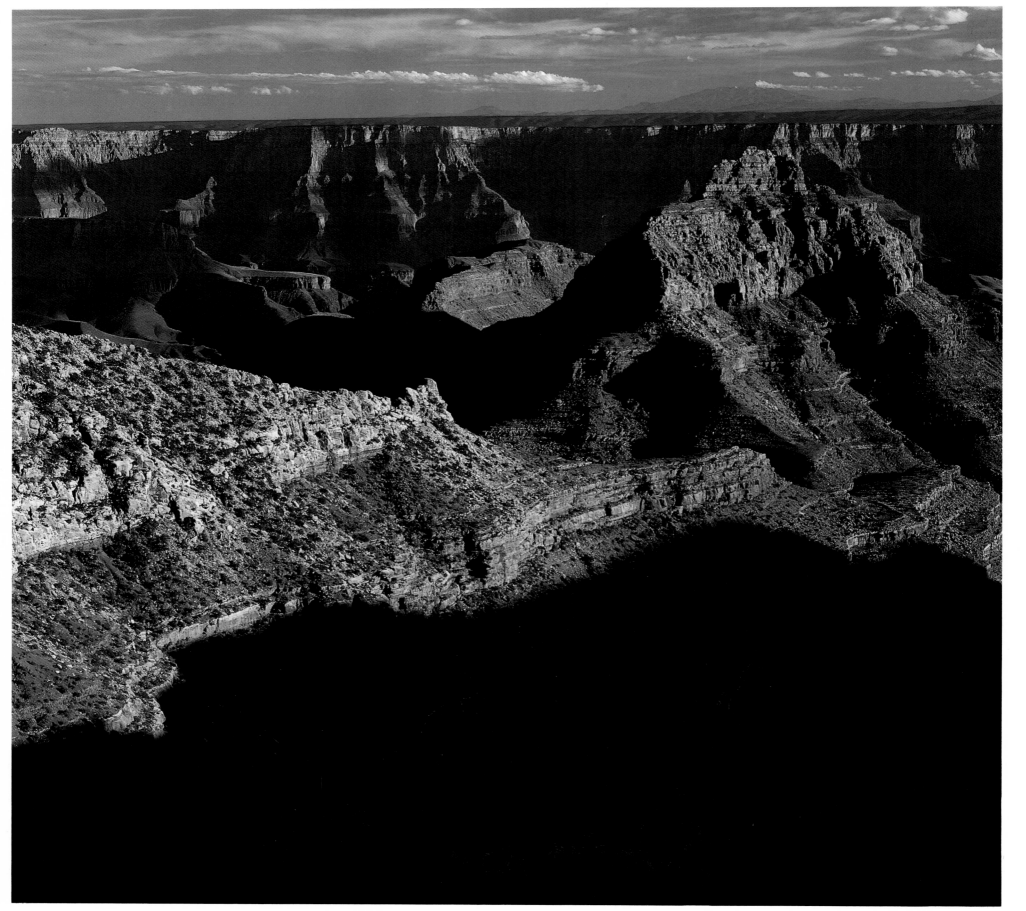

VISHNU TEMPLE FROM CAPE ROYAL. Clarence Dutton named Vishnu Temple in 1880 along with many other features in the Grand Canyon. The names of other major geologic features in the park, such as Brahma, Shiva, and Zoroaster temples, were derived from world religions, an acknowledgment that the grandeur of the Canyon is part of the heritage of the entire world.

TOROWEAP POINT AND THE COLORADO RIVER, MORNING LIGHT. Several thousand feet lower in elevation than the Kaibab and Walhalla plateaus of the North Rim, Toroweap Point is one of the few areas in the park accessible by vehicle. The view is straight down, a drop of 3000 feet to the Colorado River, and gives impressive geologic evidence of the river's enormous erosive power.

2

BLUE SPRUCE BOUGHS. The blue spruce is not a major tree species of the North Rim, but its color and symmetry add a dimension of beauty to the coniferous forests. Its close relative, the Engelmann spruce, is abundantly distributed on the Kaibab Plateau at high elevations. These hardy trees are adapted to the rigors of a severe climate and have evolved short resilient limbs easily able to shed the six to ten feet of annual snowfall.

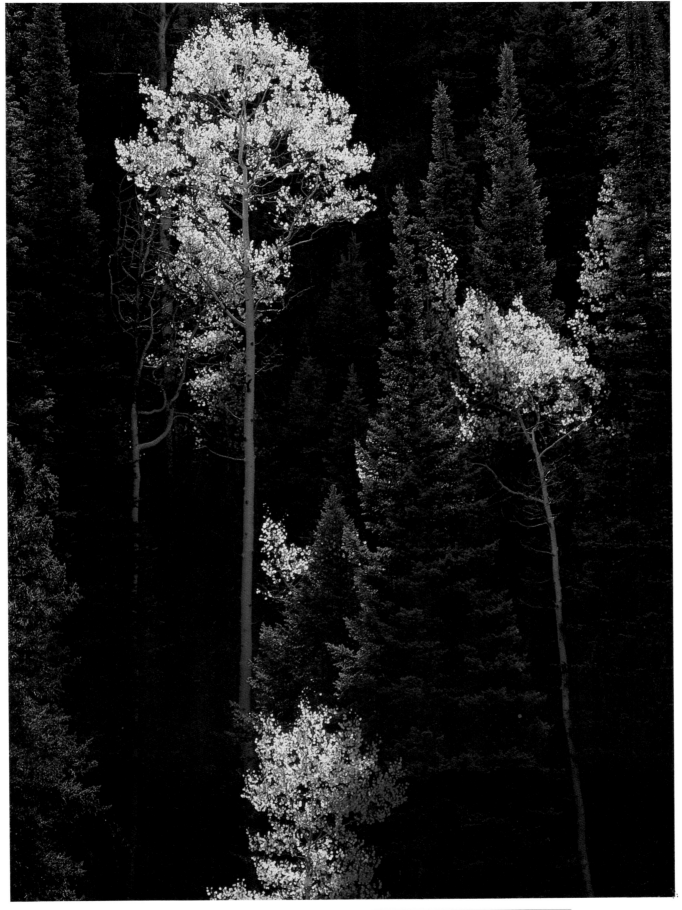

SIDELIGHTED ASPENS NEAR GREENLAND LAKE, WALHALLA PLATEAU. Aspen leaves have flat stems or petioles that cause them to tremble or quake in the breeze. Fire plays an important role in the ecology of the aspen. By killing over-mature trees, it stimulates the roots to produce new shoots that provide an essential food source for mule deer and other wildlife.

4

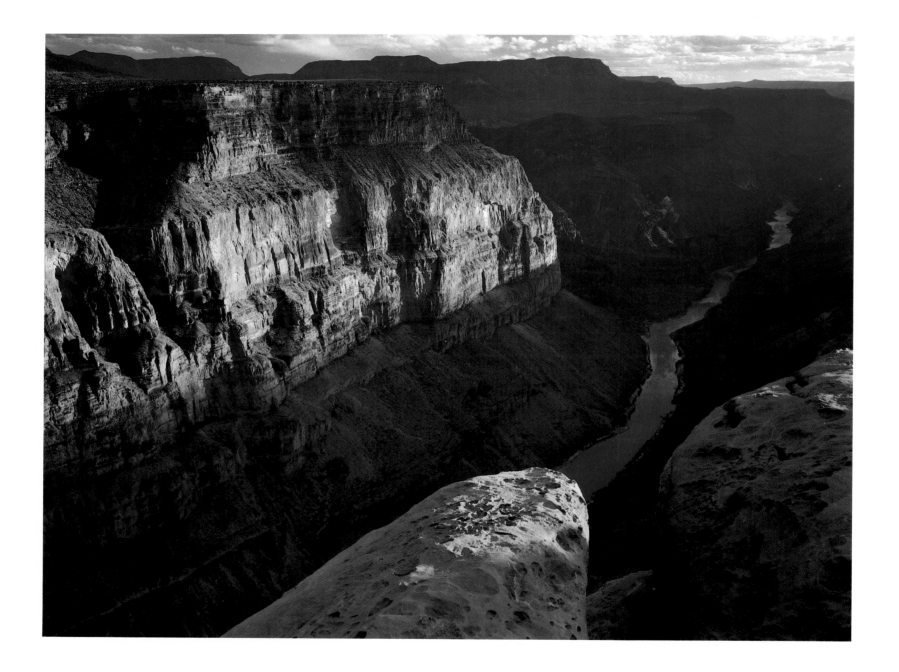

TOROWEAP POINT, VIEW TOWARD VULCAN'S THRONE AND LAVA FALLS. Some of the most recent geologic activity in the park occurred in the vicinity of Toroweap Point. Lava flowed from the Uinkaret Mountains volcanoes down what used to be Toroweap Canyon and dammed the Colorado with a massive basalt barrier. Over time, erosive action cut through the dam. Vulcan's Forge is a volcanic plug that sits midchannel in the Colorado, and for those on rafts, it announces the famous Lava Falls Rapid, one of the most treacherous rapids on the river.

6

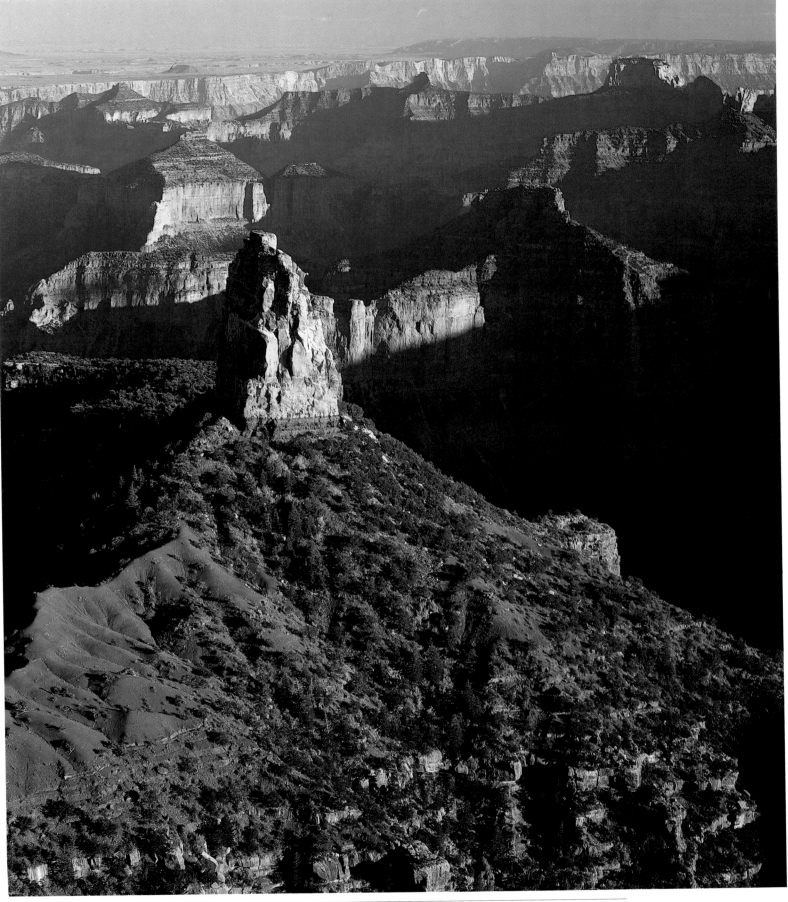

SUMMIT OF MOUNT HAYDEN ACCENTED WITH EVENING LIGHT. Few other places on the North American continent are the interrelationships of light and shadow, colors, textures, and patterns so profoundly beautiful. On any given hour of the day, the same viewpoint offers a different visual mood. Colors change with the angle and intensity of sunlight; shadows shift and disappear. Textures are brought into relief early in the morning and late in the afternoon but are lost in the maze during the flat light of midday.

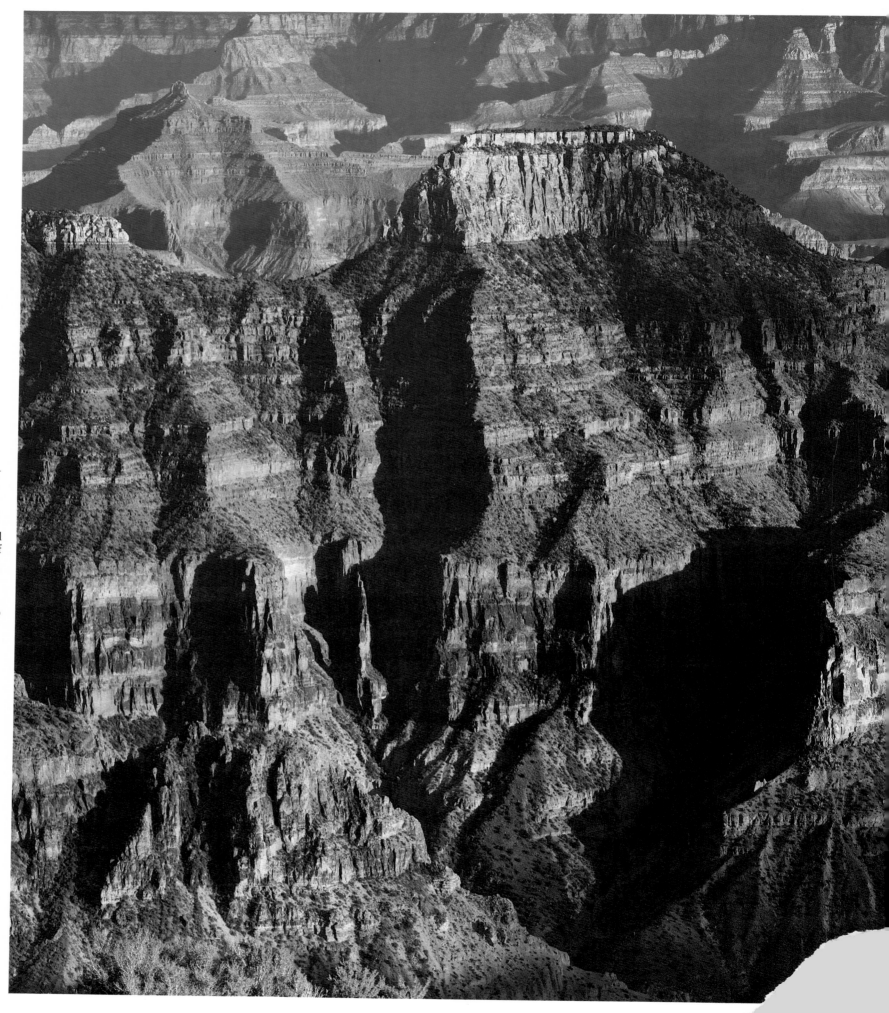

VIEW SOUTH FROM BRIGHT ANGEL POINT. A short walk from the North Rim lodge leads to Bright Angel Point and the magnificent vista to the south over Bright Angel Canyon. The prominent features of Angels Gate, Brahma Temple, and Zoroaster Temple form the mid-ground. The North Kaibab Trail leads from the North Rim down Bright Angel Creek to the Colorado River, a distance of 14.2 miles.

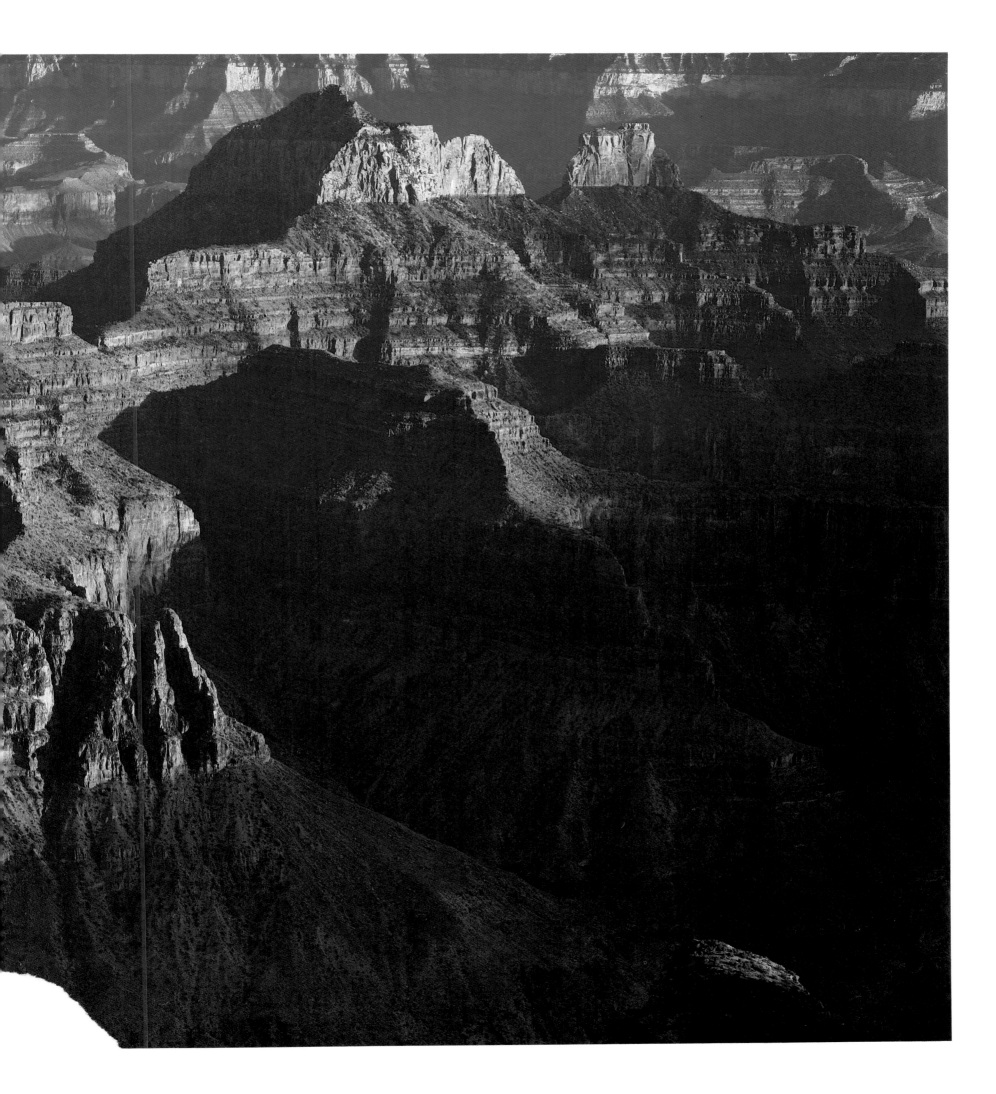

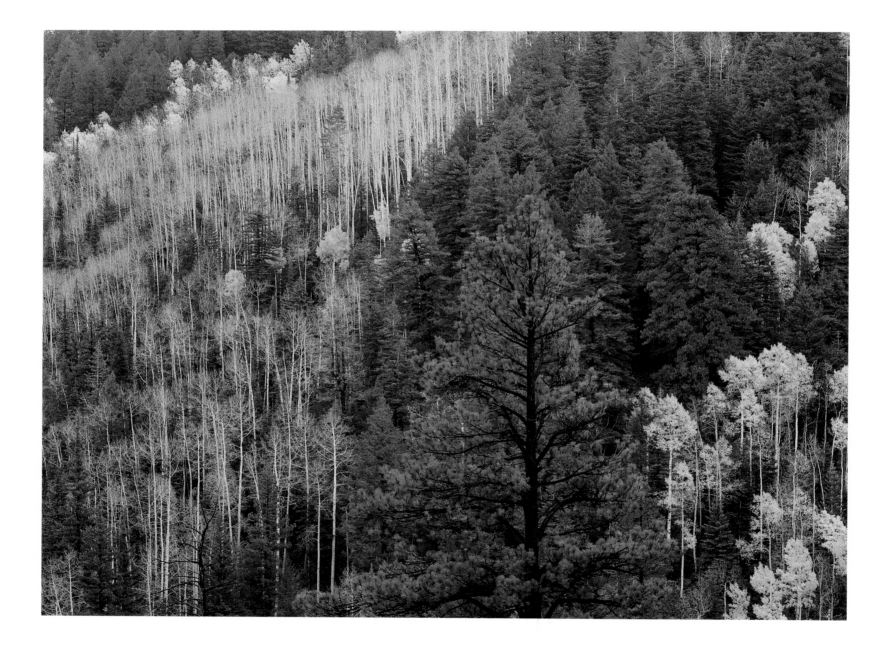

MIXED FOREST, LATE AUTUMN. The ponderosa pine (in foreground) is one of the Canyon's fire-dependent tree species. Mature ponderosa stands depend on periodic wildfires. Wildfires release nutrients from forest litter on the ground and eliminate competitors that aren't fire resistant, such as white fir. Ponderosas cover most of the Walhalla Plateau and much of the Kaibab Plateau from 7800 to 8500 feet and occasionally higher among the spruces and firs.

FOREST FLOOR DESIGN, ASPEN LEAVES AND PONDEROSA PINE NEEDLES. Trembling aspen is the dominant deciduous species on the North Rim, and ponderosa pine is one of the most abundant coniferous trees. On some sites, most commonly on the Walhalla Plateau, these two species are found growing together. Squirrels, Stellers jays, and mule deer are a few common animals that frequent this forest type.

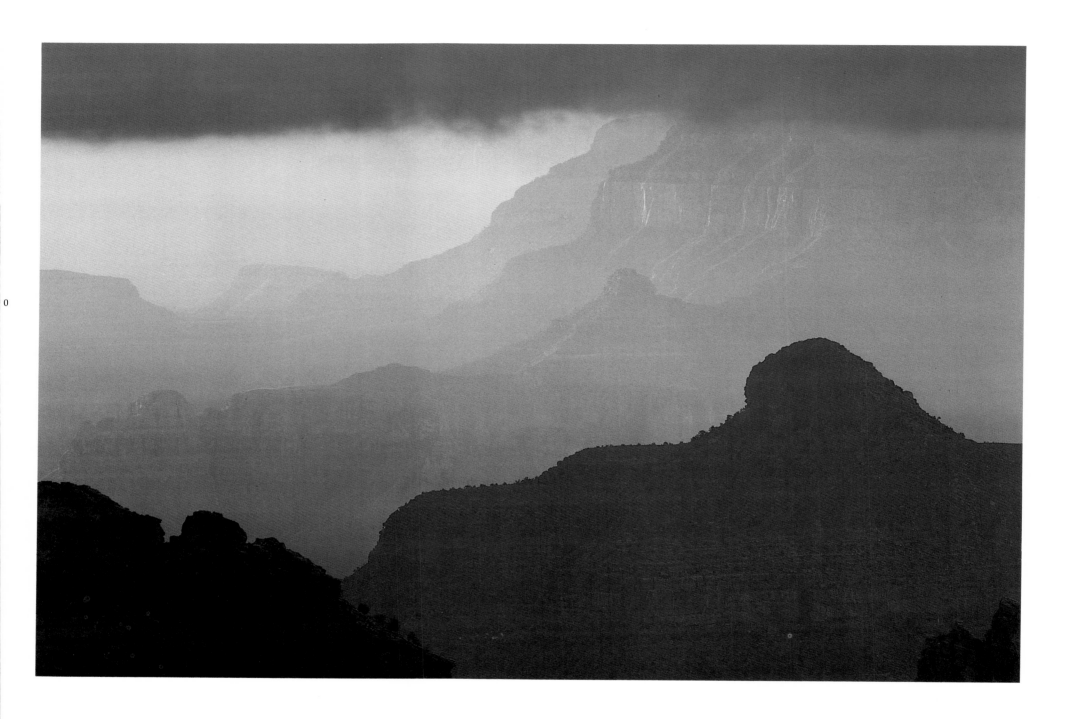

STORM INTERLUDE AND SILHOUETTED RIDGES. In 1858 Lieutenant Ives noted on his explor-
ation of the Colorado River country: "The region . . . is, of course, altogether valueless. It can be
approached only from the south, and after entering it there is nothing to do but leave. Ours has
been the first, and will doubtless be the last party of whites to visit this profitless locality." Were
he alive today, Ives' words would haunt him. Fortunately, millions have and continue to find
the Grand Canyon valuable. It is one of the most widely visited of the earth's fabled wonders.

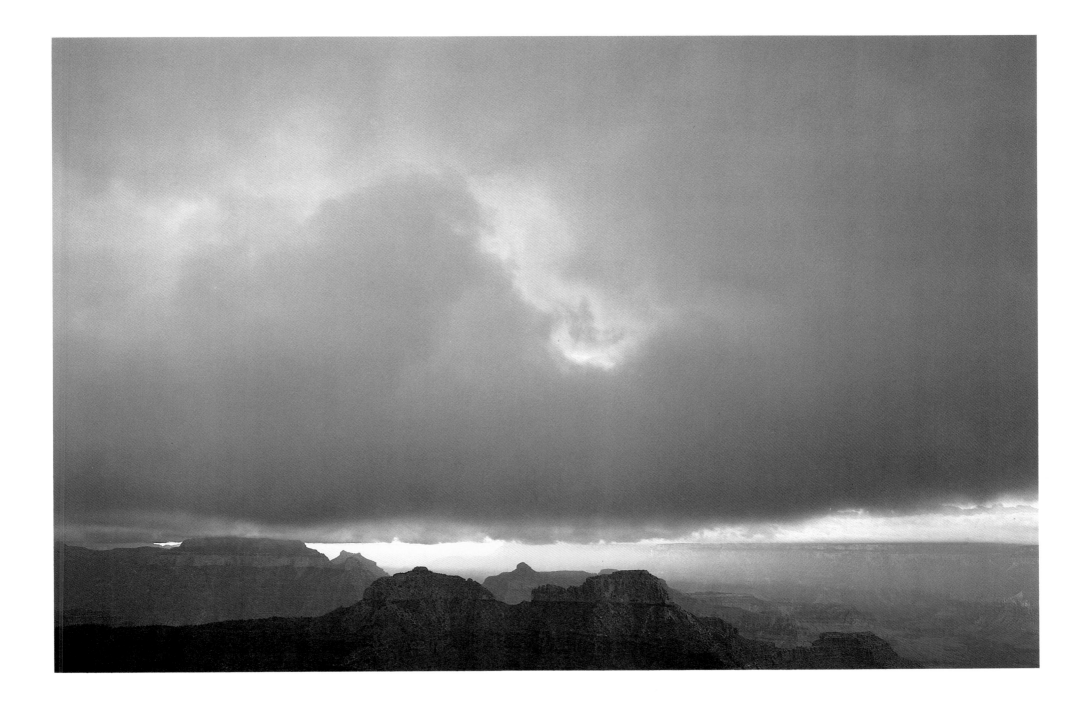

CLOUDS OVER THE INNER CANYON. As an autumn storm passes, a flood of morning light slips beneath the cloud layer and breathes life into the darkened shapes of the inner canyon. As the sun rises higher in the cleanly washed sky, and the myriad shapes of the Canyon unfold into day, we are given a taste of the primeval world—the world before cities and freeways and noise—and it sparkles to the eyes we were born with.

GRAND CANYON NATIONAL PARK
Location: Northwestern Arizona.
Established: February 26, 1919.
Size: 1904 square miles.
Elevations: North Rim 7800 to 8800 feet; South Rim averages 7000 feet.
Climate: *(North Rim)* Spring—Opens mid-May, some rain, cool days and cold nights, average high temperature 53°F, average low 28°F; summer—clear days with some thunderstorms, cool evenings, average temperatures range from 75°F to 43°F; fall—closes mid-October, temperatures similar to spring but less precipitation.
(South Rim) Open all year. Spring—some snow as late as May, average high temperature 60°F, average low 32°F; summer—rain, temperatures range from 82°F to 51°F; fall—snow possible in late October, temperatures from 64°F to 36°F; winter—snow at higher elevations, temperatures from 43°F to 20°F.
Accommodations: Full range of services at Grand Canyon Village, South Rim; lodging and tent campgrounds at North Rim.
Activities: Hiking, camping, backpacking, mule trips, river float trips, air tours, and cross-country skiing.
For more information write: Superintendent, Grand Canyon National Park, Grand Canyon, Arizona 86023.

Grand Canyon
National Park
Arizona

GRAND CANYON NATURAL HISTORY ASSOCIATION
Grand Canyon Natural History Association was organized in 1932, and more than fifty years later is continuing to aid Grand Canyon National Park in many ways on many levels. The Association, a non-profit corporation, is one of more than sixty similar cooperating associations throughout the National Park System. Authorized by Public Law 663, passed by the United States Congress in 1946, the primary function of associations is to support interpretive and related visitor-service activities of the parks.
Grand Canyon Natural History Association's main funding source is the sale of interpretive publications. The Association aids the National Park Service through continuing financial support of interpretive, educational, and research activities and each year distributes to Grand Canyon visitors more than 1,000,000 pieces of free information.

Pat O'Hara Tim McNulty

AUTHORS
Photographer Pat O'Hara bases himself in Port Angeles on Washington's Olympic Peninsula, but his work takes him throughout the country. Pat's interest in photography began in college and continued to develop while he pursued a master's degree in forest resources at the University of Washington. He has been working as a professional photographer since 1978, and some of his images have appeared in *Audubon, National Wildlife, Outside, Backpacker,* National Geographic publications, and Sierra Club and Audubon calendars. His photographs have been featured in many books on wilderness and wildlife subjects. For his work on the Woodlands Press National Park Series he has received critical acclaim. Pat's equipment for this project included several models of 4 × 5 view cameras and 35mm cameras, both systems with a variety of lenses.

Writer, poet, and conservationist Tim McNulty lives in the foothill country of Washington's Olympic Peninsula and has traveled extensively in the mountains and canyonlands of North America. Since obtaining a degree in literature from the University of Massachusetts in 1971, Tim has published numerous articles on wilderness, wildlife, and forestry issues, and his poems have appeared widely in the United States and Canada. His books of poetry include *Pawtracks,* a collection of Northwest poems, and *Tundra Songs,* a cycle of poems from Alaska. With photographer Pat O'Hara he has coauthored many books in the Woodlands Press National Park Series.

THE DESIGNERS
Since 1975, Don and Debra McQuiston of McQuiston & Daughter have been designing and producing exquisite large-format full-color books, guidebooks, and posters dealing with national and state parks and monuments. They have gained wide recognition as sensitive and imaginative graphic interpreters of our national heritage. Among the many parks and monuments they have treated are Mount Rainier, Olympic, Yosemite, Bryce Canyon, Capital Reef, Redwoods, Yellowstone, Grand Teton, Cabrillo, LBJ Ranch, and Anza-Borrego Desert. They were also coauthors of *Sandcastles,* published by Doubleday. Don and Debra live and work in Del Mar, California, just north of San Diego.

Don McQuiston Debra McQuiston

WOODLANDS PRESS
Woodlands Press develops and publishes works that celebrate the beauty of America's national heritage and the tireless efforts of those men and women who have labored to preserve it. Books are produced in collaboration with the personnel and associations of the various national parks and monuments, the National Park Service, and outstanding scientific authorities. Founded by Tokyo-based publisher Robert White and the design firm of McQuiston & Daughter, Inc., Woodlands Press is a division of Robert White and Associates, San Francisco, California.

ACKNOWLEDGMENTS
The authors wish to express their gratitude to the staff of Grand Canyon National Park and the Grand Canyon Natural History Association, particularly to Sandra Scott for her encouragement and assistance during the preparation of this book and to Jack O'Brien, Chief Interpreter of the Park, for his advice. Connie Rudd and Carl Bowman of the park's naturalist staff were extremely helpful, sharing their knowledge of the Canyon's natural history and geology and reviewing manuscript drafts. We would also like to thank naturalist Susan Lamb and archeologist Jan Balsom, as well as Dave Sharrow and John Ray of the park's Resource Division for generously offering their insights and ideas. Karen Berggren helped with library research and shared her considerable ornithological knowledge, and Nancy Brian provided a valuable perspective on the Canyon's plant life. Dr. Robert Euler of the National Park Service kindly reviewed portions of the manuscript that dealt with early human presence in the Canyon, and Bob Steelquist assisted with historical research. We'd also like to extend our thanks to typist Jerry Behrens and editor Frankie Wright as well as Tina Smith-O'Hara and Mary Morgan for their support and patience during the months this book was being prepared. And at Woodlands Press, the following also deserve our thanks: designer Eve Morris, Marci Wellens, Kristie Paulson, Lee Staicer, and Anne Miller-Randall.
A special thanks is due to George Wendt and O.A.R.S. of Angels Camp, California, and a hearty thanks to boatmen Terry Brian, Stan Boor, Mike Fabry, John French, and Alistair Charles Luther Lewis Morris (Lester) Bleifuss. They shared not only their navigational skills but their considerable first-hand knowledge of the Colorado and its matchless inner canyon.

Woodlands Press
79 San Marino Drive
San Rafael, California 94901

Distributed to the trade by Kampmann & Company, Inc., New York

Printed in Hong Kong

This book was printed and bound by Mandarin Publishers Ltd., Hong Kong, with manufacturing coordinated by Interprint, San Francisco.
The text paper is acid-free 100-pound Satin Kinfuji.
Typography was by Boyer & Brass, Inc., San Diego.
The text type is Palatino, designed by Hermann Zapf. The display type is Michelangelo, designed by Hermann Zapf.

Published by Woodlands Press, a Division of Robert White & Associates.
Photographs copyright © 1986 by Pat O'Hara.
Text copyright © 1986 by Tim McNulty.
All rights reserved. No part of this book may be reproduced in any form or by any electronic or mechanical means including information storage and retrieval systems without permission in writing from the publisher, except by a reviewer who may quote brief passages in review.
ISBN 0-917627-14-8 Softcover Edition
ISBN 0-917627-15-6 Hardcover Edition

Library of Congress Cataloging-in-Publication Data

O'Hara, Pat, 1947–
 Grand Canyon National Park.

 1. Grand Canyon National Park (Ariz.)—Description 2. Grand Canyon National Park (Ariz.)—Description— Views. I. McNulty, Tim. II. Grand Canyon Natural History Association. III. Title
F788.038 1986 917.91'32 86-1598
ISBN 0-917627-15-6
ISBN 0-917627-14-8 (pbk.)